IMAGES
of America

THE ILLINOIS
STATEHOUSE

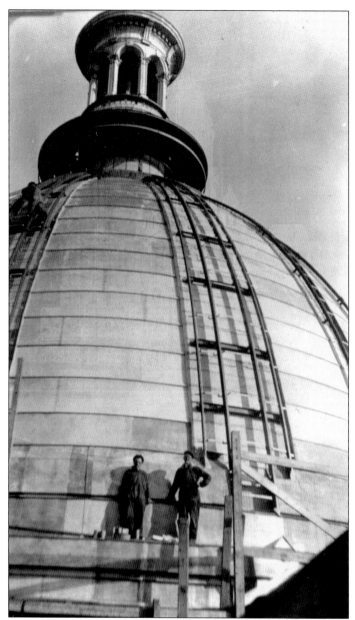

In 1932, an extensive reconstruction of the statehouse dome is underway. Years of exposure to sunlight, moisture, and Illinois weather had deteriorated the dome's structure and physical appearance. During this work, the dome was stripped down to its structural skeleton. The wooden shell was replaced with precast concrete slabs. Seen here on December 30, 1932, workers pose at the base of the new concrete shell. (Courtesy Illinois Secretary of State, Physical Services.)

On the cover: In 1954, the Centennial (now Howlett) Building, pictured on the right, has yet to be extended southwestward. This final addition was constructed in the mid-1960s. The Illinois State Archives, now known as the Margaret Cross Norton Building, is seen on the left. (Courtesy Secretary of State, Illinois State Archives.)

IMAGES
of America

THE ILLINOIS STATEHOUSE

James R. Donelan and Steven W. Dyer

Published by Arcadia Publishing
Charleston SC, Chicago IL, Portsmouth NH, San Francisco CA

Printed in the United States of America

Library of Congress Control Number: 2008942896

For all general information contact Arcadia Publishing at:
Telephone 843-853-2070
Fax 843-853-0044
E-mail sales@arcadiapublishing.com
For customer service and orders:
Toll-Free 1-888-313-2665

Visit us on the Internet at www.arcadiapublishing.com

To the citizens of Illinois who own this temple.
To our families who made it possible for us to share this treasure.

Contents

ACKNOWLEDGMENTS

We would like to express our gratitude to all who have helped with this publication. This book would not have been possible without the support and patience of our families.

Our thanks go to Arcadia Publishing and our editor, Jeff Ruetsche, for accepting our proposal and encouraging us to move forward and to production editor Sarah Fournier.

We are especially grateful to the following individuals whose friendship and assistance helped pave our way: Brad Bolin, Ron Cooley, Rick Davis, Linda Garvert, Jan Grimes, Kathryn Harris, Linda Hawker, Heather Hayes, Mal Hildebrand, Keith Housewright, David Joens, Scott Kaiser, Mark Mahoney, Curtis Mann, Dean McGeath, Mary Michals, John Reinhardt, Steve Sarver, Deb Shipley, Mark Sorensen, and Dr. Wayne "Doc" Temple.

Unless otherwise noted, all images are courtesy of www.ilstatehouse.com.

INTRODUCTION

Springfield is a city rich in history. The names of Abraham Lincoln, Vachel Lindsay, Ulysses S. Grant, Frank Lloyd Wright, and Barack Obama reverberate through its streets. Like the other 49 capital cities in the United States, government is an essential part of the daily lives of its citizens. What sets Springfield apart in most people's minds is its tie to its favorite son, Abraham Lincoln. Most schoolchildren know that Lincoln was from Illinois, and a considerable portion probably have a general idea he is from Springfield. However, what most may not understand is that Springfield owes its capital city title to the country's 16th president.

During the 1836–1837 general assembly, a group of legislators from the Springfield area shared not only similar political beliefs but physical stature as well. These nine men, each over six feet tall, became known as the Long Nine. Lead by state representative Abraham Lincoln, the eight others were Senators Job Fletcher and Archer G. Herndon and Representatives John Dawson, Ninian W. Edwards, William F. Elkin, Andrew McCormick, Daniel Stone, and Robert L. Wilson. Together they held a key voting block and the influence to change the direction of the legislature. In 1837, the group led a successful effort to move the capital city to Springfield. The general assembly voted to move the capital, and Springfield became the state's seat of government in 1839.

The newly constructed capitol building in Springfield, today known as the Old State Capitol, became the state's fifth statehouse. Here Lincoln delivered his famous House Divided speech in 1858 when he so eloquently spoke the words "A house divided against itself cannot stand," referring to the division in America of slave and free states. Only seven years later after an assassin's bullet struck him down, President Lincoln would lie in state in Representatives Hall.

By 1867, the legislature realized that it was outgrowing its statehouse and passed legislation calling for the construction of a new building in Springfield to house state government. Ground was broken on the new statehouse on March 11, 1868. Taking 20 years to complete and standing at 405 feet tall to the tip of the flagstaff, the structure's magnitude exhibits the beauty and statesmanship that has been experienced for nearly 120 years. With Springfield's ties to Lincoln, and the fact that the statehouse is an active seat of government, a full appreciation of its significance is sometimes a struggle. People have forgotten its heritage and how portions of this great structure were dedicated to the memory of the fallen soldiers of the Civil War. Governors, mayors of Chicago, and even a president have served within this great building. The building captures the architectural beauty of the late 19th century while, at the same time, holding on to its abundant political and social history.

The statehouse has endured several changes over the years. Some have been good, and some have not. Floors have been added, artwork painted over, and furnishing lost to the ages. Even

as recent as the early 1990s, it seemed as if bringing the building back to its 1890s glory was an unreachable task. However, in recent years, the Capital Development Board, senate and house leadership, the secretary of state, and the Office of the Architect of the Capitol have completed dramatic historic improvements and renovations to the building. Special attention has been given to historical accuracy, and the colors and grand look of the late 19th century are returning.

In 2001, the authors of this publication began discussing the possibility of a book dedicated to the present Illinois Statehouse. A decision was soon made by the authors to begin this project with the development of a Web site devoted to the building. During the spring of 2002, the site was officially launched, www.ilstatehouse.com. Since that time, over 85,000 visitors have viewed the site, and the domain has been featured in numerous publications and enjoyed by people with an elementary and scholarly interest alike.

The authors have worked in and around the statehouse for a combined 50-plus years and are interested in preserving its history and sharing its story for present and future generations. Their goal is for this publication to serve as an informational and educational resource for its readers and encourage more and more visitors to Springfield and its statehouse.

One

CONSTRUCTION

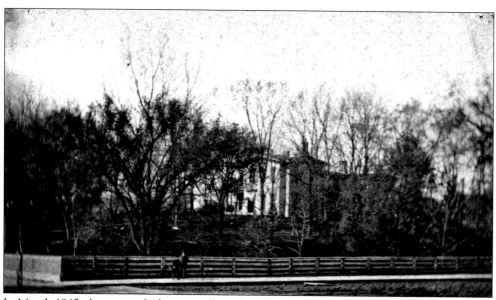

In March 1865, three years before ground was broken for the present statehouse, a house owned by the Mather family stood on the site. Only a few weeks later, the Mather site was chosen by the Abraham Lincoln Monument Association as the location for Lincoln's tomb. A temporary vault was constructed. Instead, this tomb went unused, and Lincoln was interred at Oak Ridge Cemetery, just north of Springfield. In 1867, the State of Illinois acquired the ground to erect the current statehouse. (Courtesy Abraham Lincoln Presidential Library.)

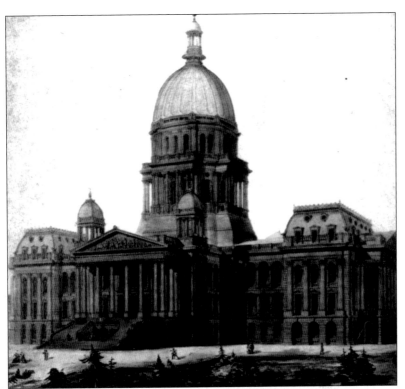

This is one of many artist renderings of the statehouse prior to its completion.

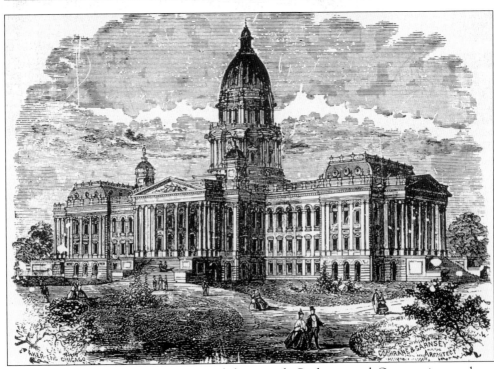

An early drawing from the architects of the capitol, Cochrane and Garnsey, is seen here. (Courtesy Office of the Architect of the Capitol.)

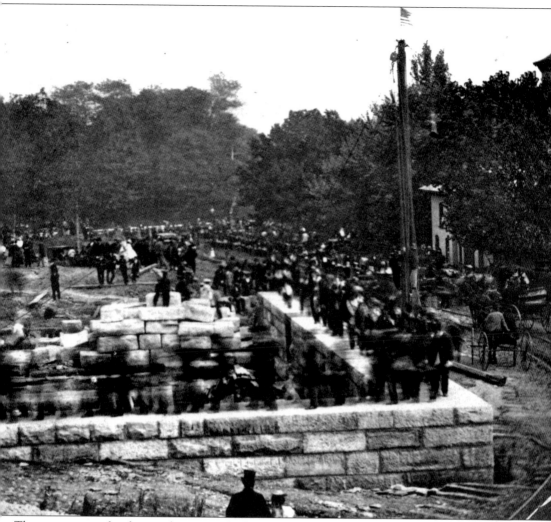

The cornerstone for the statehouse was laid on October 5, 1868, during ceremonies officiated by the Illinois Masonic Lodge. The workers marched two abreast in a procession along the foundation of the building until they reached the spot where the cornerstone was to be placed. Note the railroad tracks, which facilitated the delivery of stone and other building materials. (Courtesy Abraham Lincoln Presidential Library.)

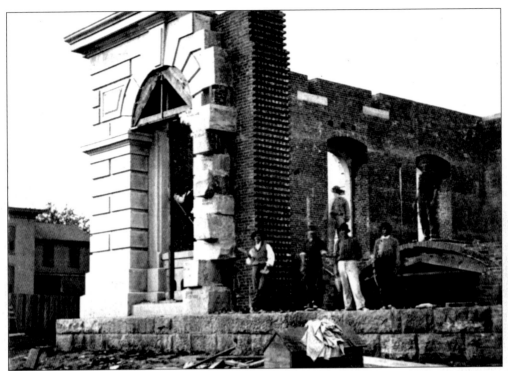

The interior walls of the statehouse consist of many rows of bricks. This image details just how thick the walls are. Houses were still located near the site during the building's construction, as seen in the background. (Courtesy Sangamon Valley Collection, Lincoln Library.)

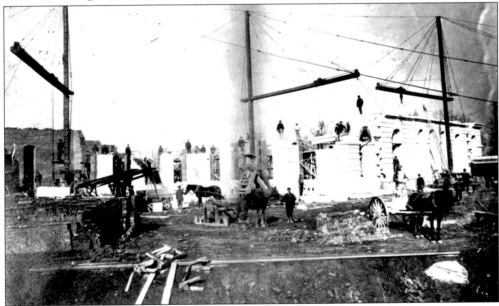

Today motorized cranes and equipment are commonplace on construction sites. However, during the late 19th century, wooden derricks utilizing a block and tackle system were employed to lift heavy materials such as limestone and bricks during construction. (Courtesy Abraham Lincoln Presidential Library.)

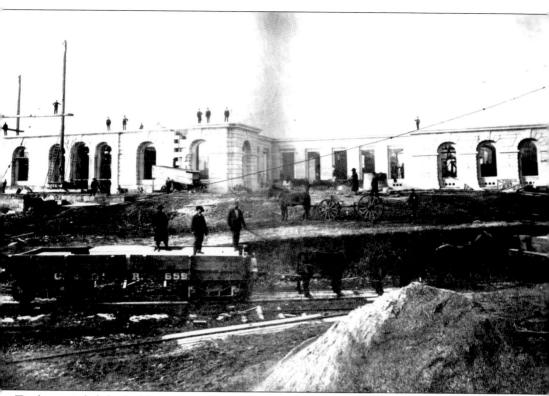

Tracks encircled the building site and horse-drawn railcars were used to deliver materials. The first floor is beginning to take shape as workers pose for this photograph. (Courtesy Abraham Lincoln Presidential Library.)

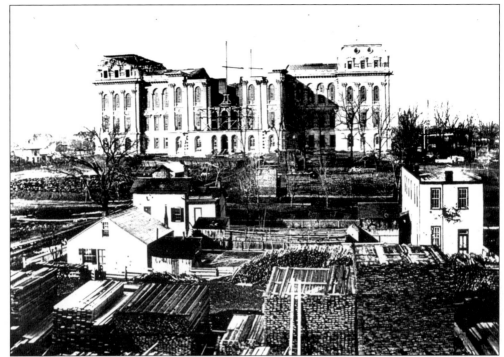

Building materials were a constant sight around the statehouse grounds throughout its 20-year construction. The mansard wings (far left and right) are nearing completion in this *c.* 1874 image. Although the stairway to the second-floor entrance has not been completed, scaffolding is visible in front of the planned entrance. (Courtesy Office of the Architect of the Capitol.)

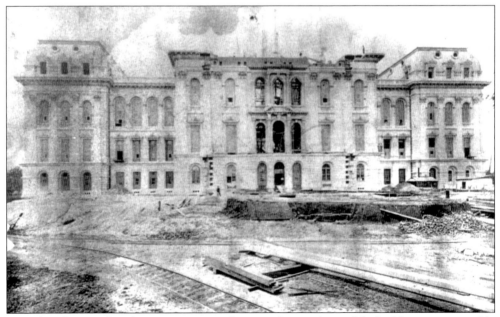

Even though it is still under construction at the time, the east front of the building is recognizable in this photograph from the mid-1870s. (Courtesy Office of the Architect of the Capitol.)

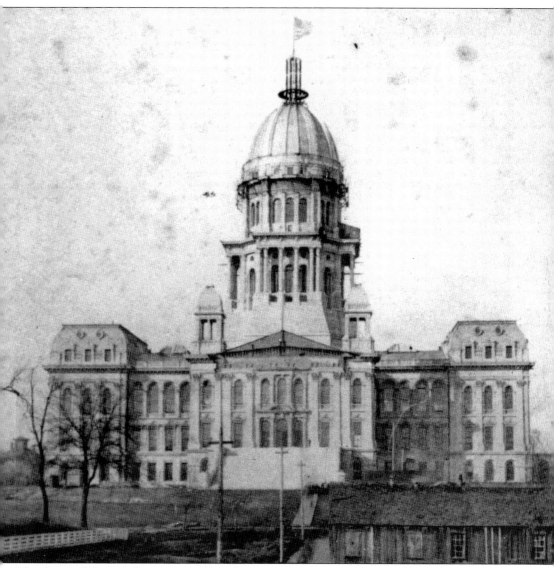

The dome of the statehouse was still under construction around 1880 (above). The U.S. flag has flown over the statehouse since at least February 22, 1876, when it was lifted atop a derrick used for construction of the dome. It was hoisted on the statehouse flagpole for the first time on November 29 of the same year. (Courtesy Abraham Lincoln Presidential Library.)

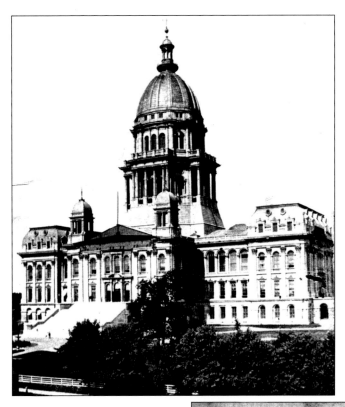

Until 1885, the main entrance to the statehouse was located on the current second floor (east). Access was gained by way of a massive exterior staircase. Upon removal of the steps, what was considered the basement became the first floor, and artistic improvements were made to enhance this level. (Courtesy Abraham Lincoln Presidential Library.)

Seen in this c. 1885 photograph, as the building nears completion the grounds are still devoid of large trees and other landscaping. The portico of the senate wing has not been finished (right).

Two

FIRST FLOOR

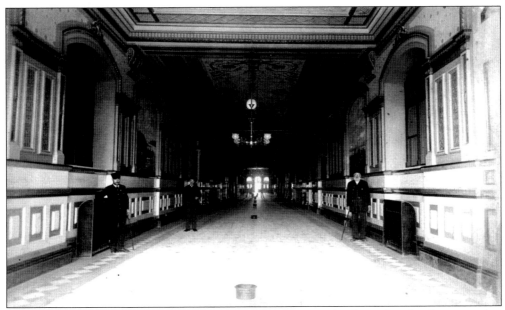

Medallion portraits of U.S. presidents were painted in panels along this first-floor corridor. Sometime during the early 20th century, they were painted over and remained lost until 2002. The paintings were restored during the recent renovation of this area. Note the absence of the *Illinois Welcoming the World* statue in the center of the rotunda. It was placed there in May 1895. (Courtesy Abraham Lincoln Presidential Library.)

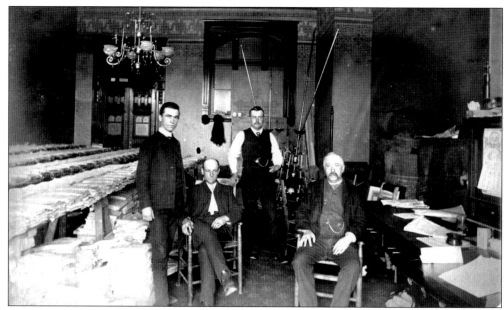

The first floor has housed many different offices over the years. Although the exact use of this room is unknown, this 1887 view was taken during the completion of the building. The depiction of the statehouse on the window ledge in the background and chandeliers awaiting installation are of particular interest in this photograph. The gentlemen pictured are in the southern portion of present-day House Committee Room 114. The wall on the left was removed many years ago. (Courtesy Abraham Lincoln Presidential Library.)

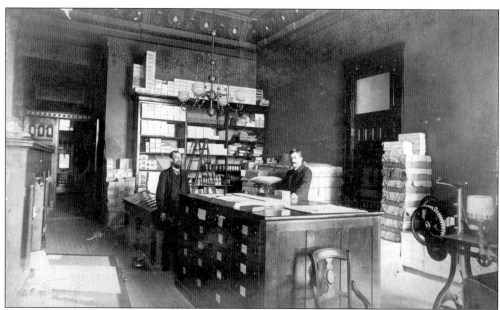

Today many offices in the statehouse have the luxury of personal computers and other forms of technology. This first-floor office in 1887 does not employ these modern marvels. However, it does have a few conveniences of the day. (Courtesy Abraham Lincoln Presidential Library.)

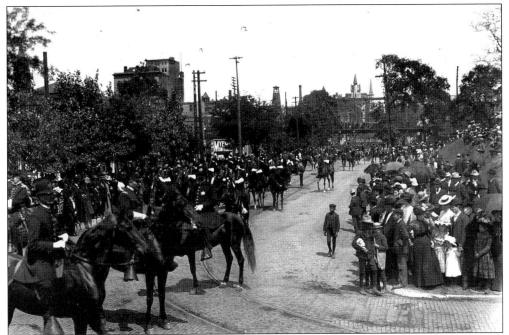

Gov. John R. Tanner (1897–1901) died on May 23, 1901, just five months after he left office. Seen here is a view of his funeral procession in front of the statehouse on Capitol Avenue. (Courtesy Abraham Lincoln Presidential Library.)

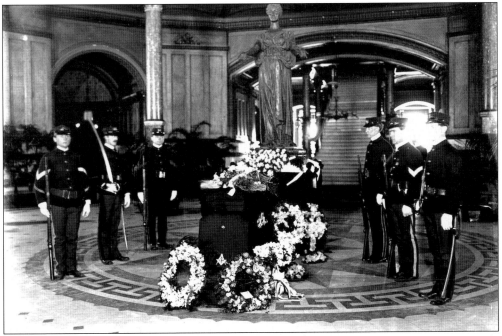

Governor Tanner was the first governor to lie in state in the rotunda, and over 30,000 people filed past his casket. The *Illinois Welcoming the World* statue, seen here with arms outstretched, was sculpted by Julia Bracken. Interestingly, Bracken cast a death mask of the governor at the request of his family and friends. (Courtesy Abraham Lincoln Presidential Library.)

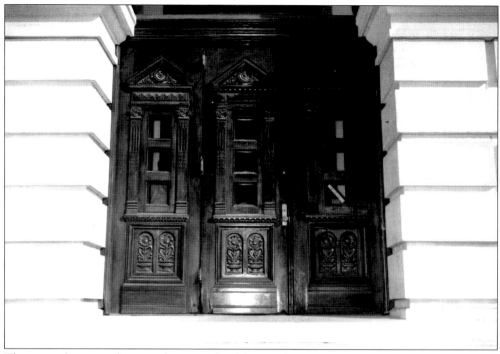

The original exterior doors on the west side of the statehouse were still in use in September 1956. (Courtesy Secretary of State, Illinois State Archives.)

The doors to the north entrance have been replaced several times over the years. As illustrated here, construction workers are modifying the doorway during the mid-1950s. (Courtesy Secretary of State, Illinois State Archives.)

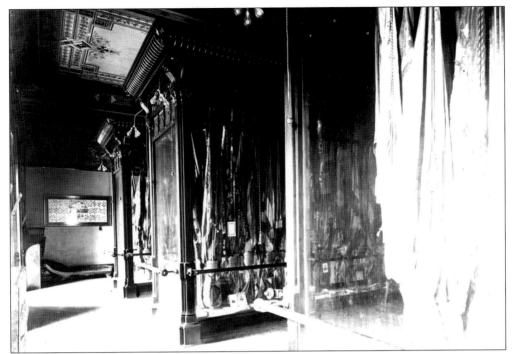

Illinois Civil War battle flags were housed in the statehouse's first-floor Memorial Hall (above). The flags were displayed at three different statehouse locations from 1878 to 1924, when they were moved to the Hall of Flags in the Centennial (now Howlett) Building. In September 2003, the flags were taken off display and stored at the Illinois Military Museum at Camp Lincoln for eventual restoration. (Courtesy Abraham Lincoln Presidential Library.)

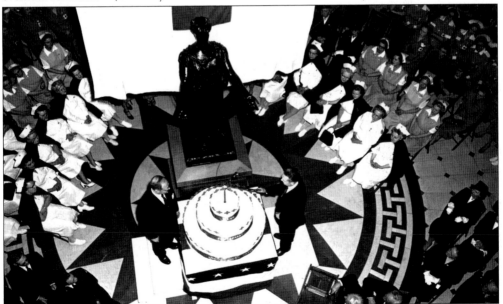

As seen from the second floor, Gov. William G. Stratton (1953–1961) lights a candle on a cake commemorating the 75th anniversary of the American Red Cross during ceremonies held on March 2, 1956. (Courtesy Secretary of State, Illinois State Archives.)

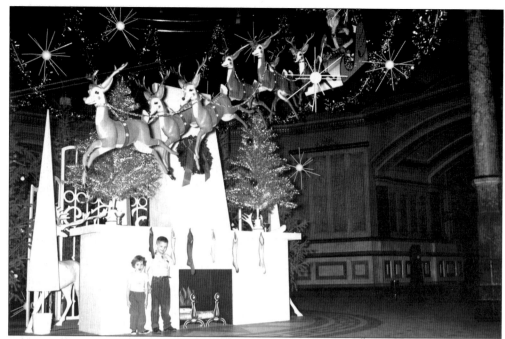

Rotunda Christmas displays were once much more elaborate and have been a favorite of children for many years. These two unidentified youngsters had their picture taken on December 31, 1955. (Courtesy Secretary of State, Illinois State Archives.)

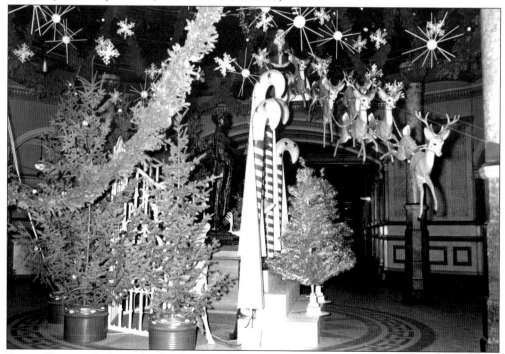

Santa Claus made his annual visit to the statehouse during Christmas 1956. Although the decorations have changed over the years, the first floor has been home to holiday displays as far back as anyone can remember. (Courtesy Secretary of State, Illinois State Archives.)

Statehouse tour guides display their new uniforms on June 8, 1976. The souvenir/snack stand visible on the left has since been moved and is presently located at the rear of the stairway visible behind the Illinois Welcoming the World statue. (Courtesy Secretary of State, Illinois State Archives.)

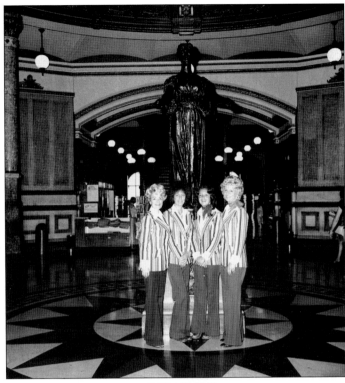

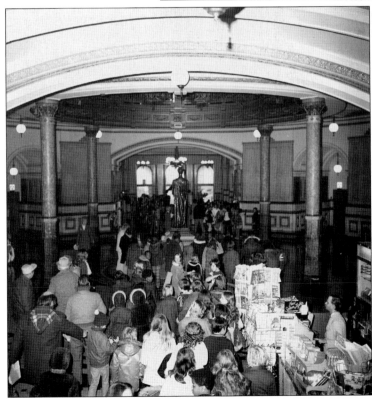

The statehouse has been a popular destination for school groups and tourists for many years, as evidenced by this rotunda scene from 1975. (Courtesy Secretary of State, Illinois State Archives.)

Many areas of the first floor have been restored recently. A sample of the south corridor in 2007 showcases a section returned to late-19th-century decor, including extensive stenciling and painting.

In 2008, 12 presidential portraits were uncovered, re-created on canvas, and returned to their original first-floor locations. Illinois' favorite son and the 16th president, Abraham Lincoln, is featured in this grouping.

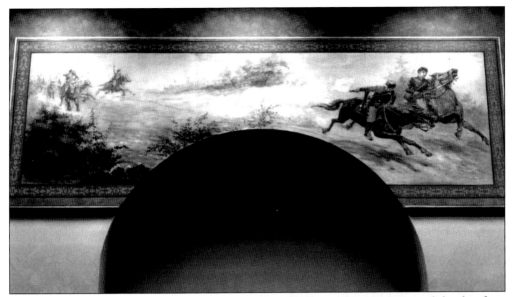

Room 115, located in the southwest corner of the statehouse, was once part of the first-floor Memorial Hall. A Civil War mural located on an upper wall was recently uncovered and restored.

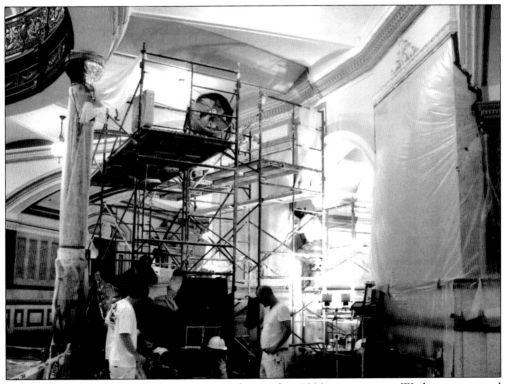

In 2006, the first-floor rotunda was returned to its late-1880s appearance. Workers uncovered and re-created stenciling throughout this area.

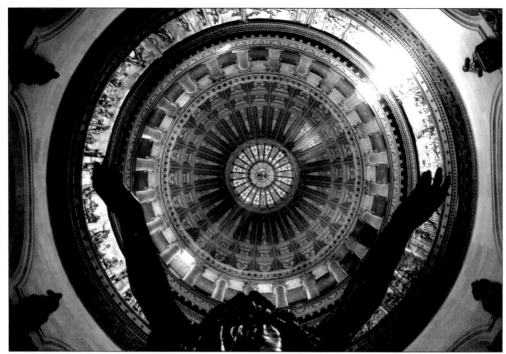

A ray of sunlight shines between the arms of the *Illinois Welcoming the World* statue from the dome windows above.

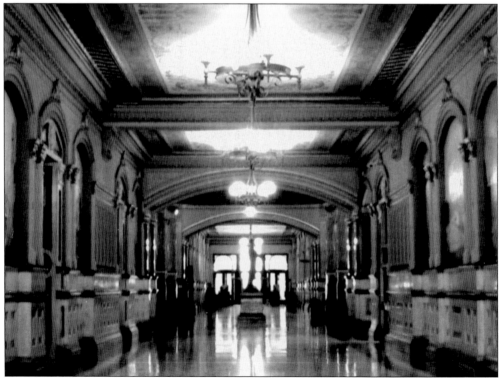

This is a 2008 view of the first floor, south corridor looking north, after a recent renovation.

Three

SECOND FLOOR

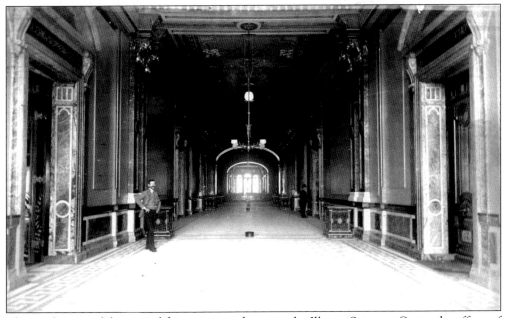

The south wing of the second floor was once home to the Illinois Supreme Court, the offices of the supreme court clerk, and the superintendent of public instruction. The view of the windows at the end of the corridor no longer exists due to the construction of the Illinois comptroller's office in the early 1970s. (Courtesy Abraham Lincoln Presidential Library.)

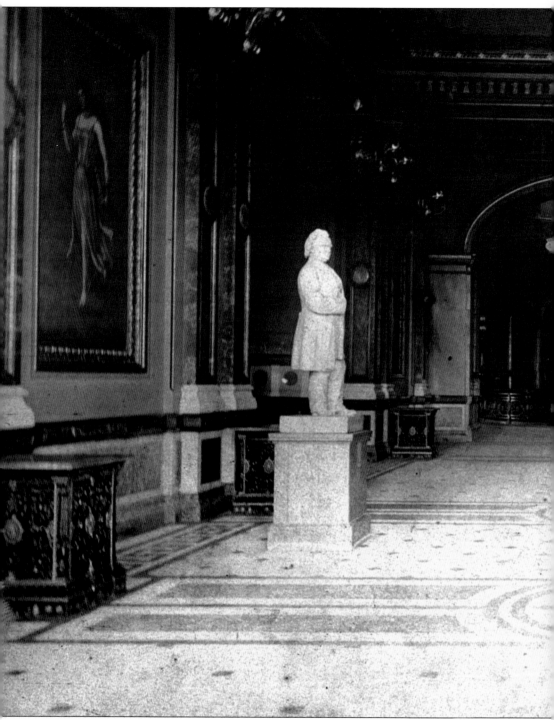

The second floor was originally the main entrance to the statehouse. Lining the once public area are four murals representing art, literature, peace, and war. There were also exceptional plaster statutes of Abraham Lincoln (right) and Stephen A. Douglas (left), both sculpted by Leonard Volk, and Gov. John Wood (rear), created by Volk's brother, Cornelius. Two of the

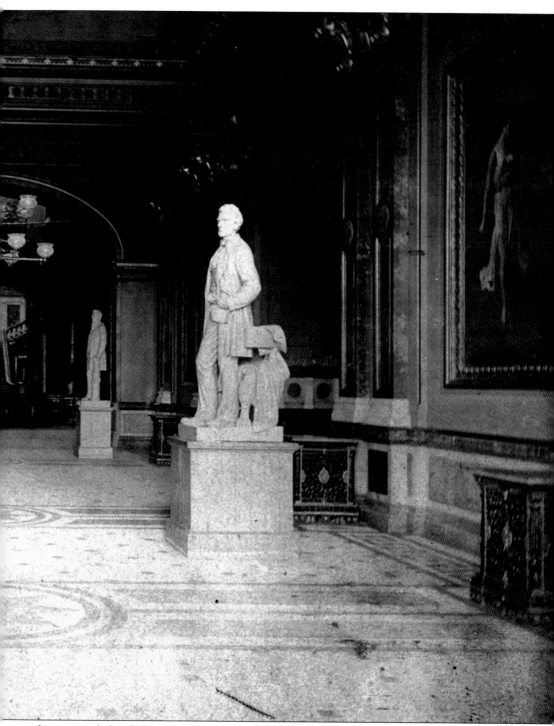

murals are now behind the glass partition of the governor's office, and the statues are among those of eight Illinoisans honored on second-floor pedestals. (Courtesy Abraham Lincoln Presidential Library.)

These doors once served as the main entrance to the building and now provide access to a private balcony outside the governor's office. The now seldom-used doors are watched over by an American eagle (below).

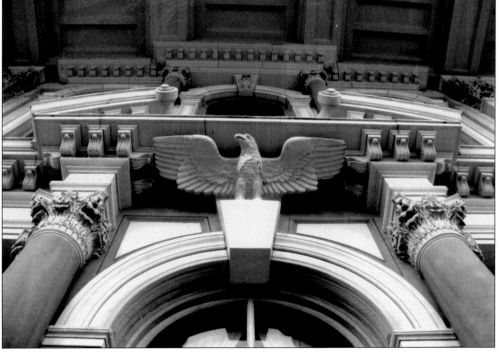

Richard J. Oglesby has the unique distinction of being governor when ground was broken on the statehouse in 1868 and again when the building was completed in 1888. He served three nonconsecutive terms of office, 1865–1869, 1873, and 1885–1889. The original governor's office was located just inside the old main entrance to the right. Oglesby is responsible for nicknaming Abraham Lincoln the "Rail-splitter" and was present at his deathbed. (Courtesy Abraham Lincoln Presidential Library.)

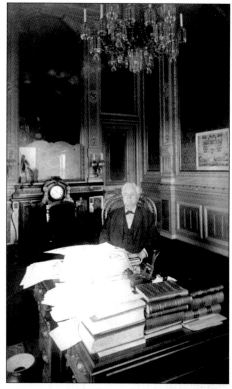

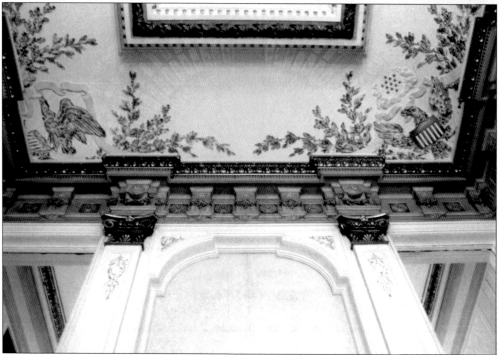

Here is the ceiling in the governor's original private office in 2004. The ceiling depicts the Illinois State Seal (left) and the Great Seal of the United States (right).

The governor's office is pictured here in 1902. (Courtesy Abraham Lincoln Presidential Library.)

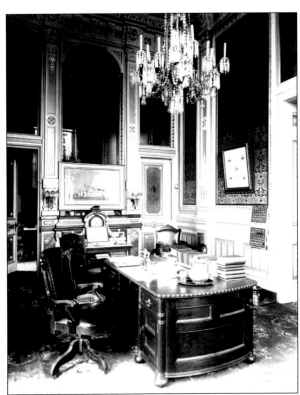

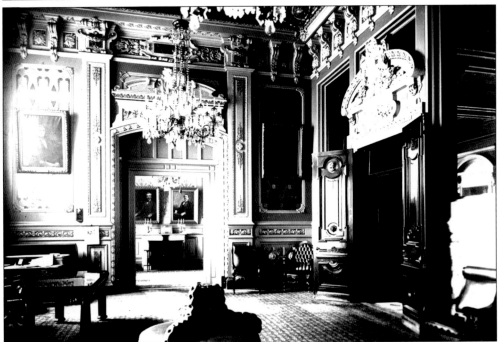

Prior to the governors' portraits being placed in the Hall of Governors, they could be viewed in the governor's reception room. This room is now the personal office of the governor. (Courtesy Abraham Lincoln Presidential Library.)

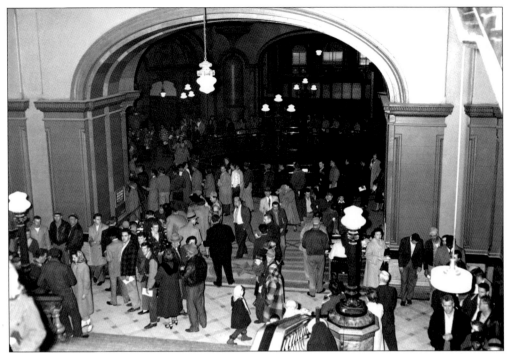

Before the ceiling-high glass wall was constructed to enclose the governor's office, a combination wooden and glass structure created an office space, as seen here in the background in January 1958. (Courtesy Secretary of State, Illinois State Archives.)

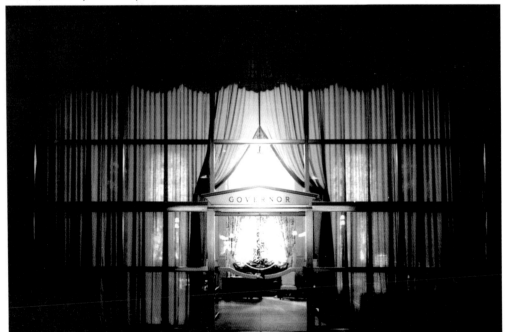

The governor's office used to be a more private space due to drapes hung behind the glass wall. The original main entrance to the statehouse (now opening to a second-floor balcony) is seen at the rear of the governor's office. (Courtesy Secretary of State, Illinois State Archives.)

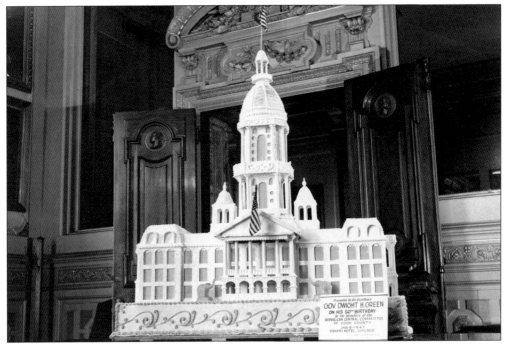

Gov. Dwight Green (1941–1949) celebrated his 50th birthday in 1947 and was presented with a cake in the shape of the statehouse. The cake is seen in the governor's office. (Courtesy Secretary of State, Illinois State Archives.)

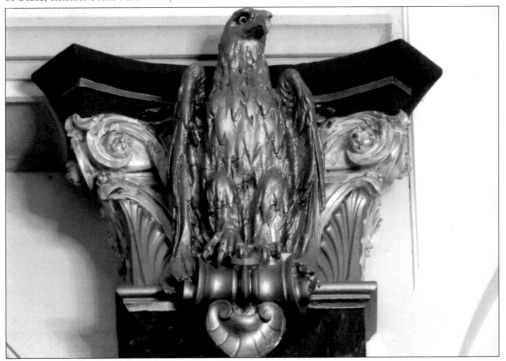

A pair of gilded American eagles is perched atop the columns just inside the original entrance to the building.

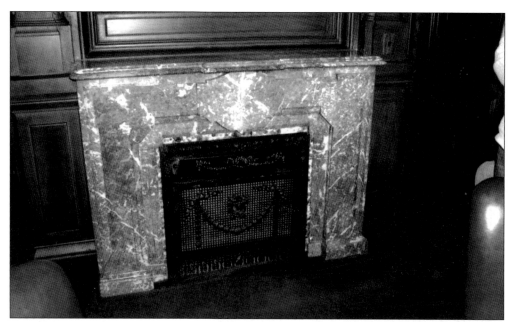

Seen here on April 7, 2004, originally the secretary of state's private office, this room is now the office of the governor's chief of staff. The fireplace may be seen behind Secretary of State Henry D. Dement in the image below.

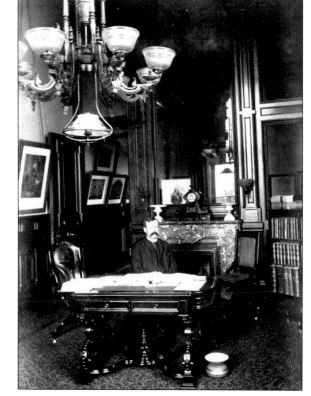

Originally, when entering the second-floor main entrance, directly left was the secretary of state's office. Henry D. Dement (1881–1885) is seen here seated at his desk. A Civil War veteran, Dement was known to fire a shotgun from the roof of the statehouse to dislodge the pigeons that roosted on the dome. (Courtesy Abraham Lincoln Presidential Library.)

The secretary of state's office used to be located directly across from the governor's office in the east corridor of the second floor, just inside the original main entrance. The official state seal sat upon the counter inside, as shown here. (Courtesy Secretary of State, Illinois State Archives.)

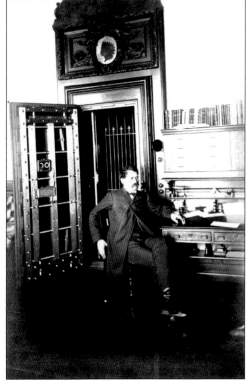

Located on the second floor, the Illinois state treasurer's office has been in the same area since completion of the building. Treasurer John R. Tanner (1887–1889), who later served as governor, is seen in this photograph. The exact location of the vault is hard to pinpoint due to changes made to the office over the years. (Courtesy Abraham Lincoln Presidential Library.)

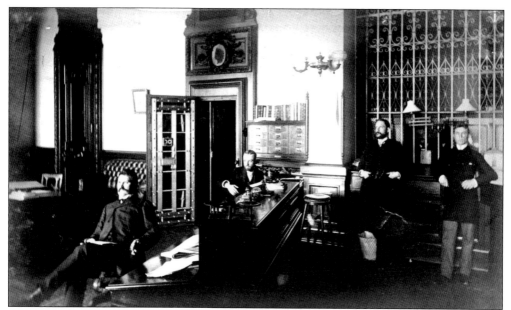

Although the armored doors have been removed, some rooms in areas of the building under control of the state treasurer in the present day still have thick concrete walls and ceilings that tell of their past use as vaults. (Courtesy Abraham Lincoln Presidential Library.)

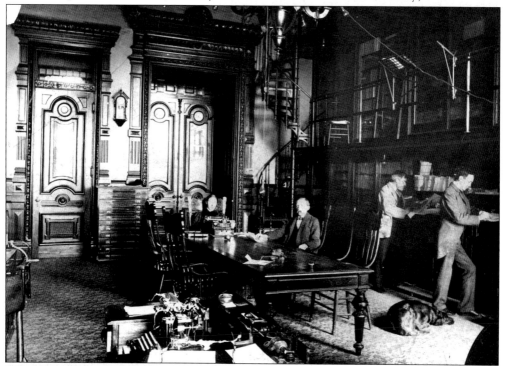

Spiral staircases once connected several offices on adjacent floors or to a second tier of bookshelves or storage within the same room. These steps were gradually phased out of the building due to the installation of several elevators and the creation of several mezzanine floors. (Courtesy Abraham Lincoln Presidential Library.)

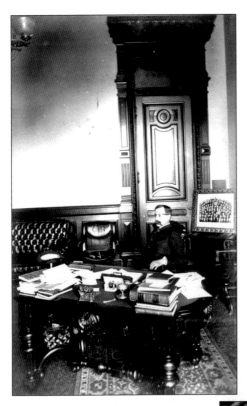

State auditor Charles Swigert (1881–1889) lost his right arm during the Civil War. The "Logan 103" may be seen behind Swigert. It is an image of Gen. John A. Logan surrounded by those Illinois legislators who voted to send him to the U.S. Senate in 1885. This collage could be seen in several statehouse offices during this period. (Courtesy Abraham Lincoln Presidential Library.)

The Illinois Supreme Court met in the statehouse until 1908 when the present supreme court building (east of the capitol) was completed. The most ornately decorated area in the statehouse, Room 212, now serves as a senate committee hearing room. (Courtesy Abraham Lincoln Presidential Library.)

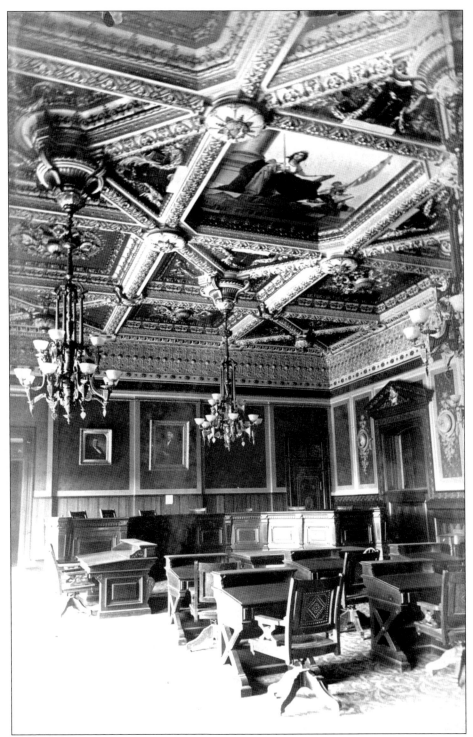

In this early view of the supreme court chamber, a painting of the goddess of justice may be seen on the ceiling. She is trampling on coins, indicating that justice cannot be bought. (Courtesy Abraham Lincoln Presidential Library.)

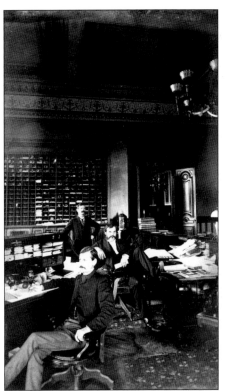

The area occupied today by the lieutenant governor was once the office of the clerk of the supreme court. Ethan Allen Snively, who held that office in 1887, is seated in the foreground, and behind him is George W. Jones, clerk of the appellate court. These Democratic state office holders from Macoupin and Pike Counties were the reason the southwest corner of the second floor was nicknamed the "Confederate Corner." The supreme court chamber may be seen through the door. (Courtesy Abraham Lincoln Presidential Library.)

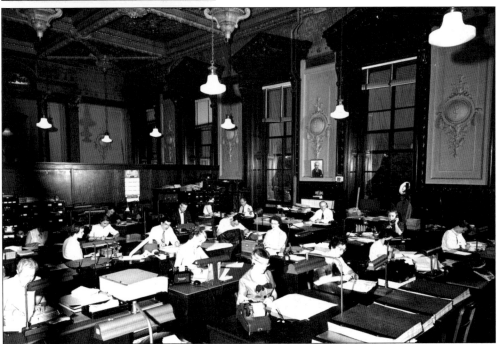

The ornate ceilings and law-related decor of the former supreme court chamber are visible in this August 1954 photograph of secretary of state employees working in what is today known as Senate Committee Room 212. (Courtesy Secretary of State, Illinois State Archives.)

Although Abraham Lincoln never served in the current statehouse, his presence is definitely felt. Several statues and portraits of the Great Emancipator may be seen in the building and on the grounds. Local officials proposed building his tomb on the site three years before ground was broken for the statehouse.

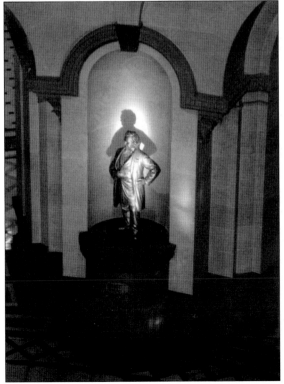

Placed in the statehouse in 1877, the statues of Stephen A. Douglas, Abraham Lincoln, and Gov. John Wood are today painted to resemble bronze. Renowned sculptor Leonard Volk crafted this second-floor statue of Stephen A. Douglas. One of Volk's claims to fame is that he cast a life mask of Lincoln and plaster molds of his hands during the 1860 presidential race (Lincoln's right hand was swollen from shaking so many hands).

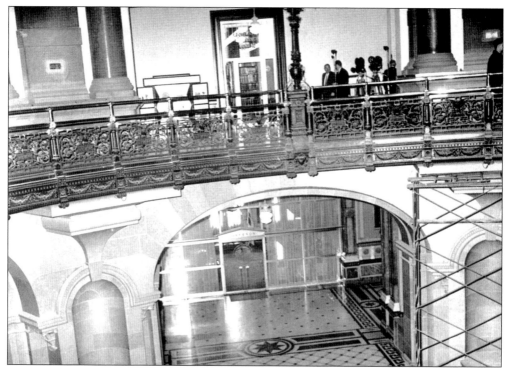

The Legislative Reference Bureau was once housed on the third floor in Room 300. The empty alcoves visible on the second floor are now occupied by statues of former Illinois legislator and Chicago mayor Richard J. Daley and Illinois' first female legislator, Lottie Holman O'Neill. (Courtesy Secretary of State, Illinois State Archives.)

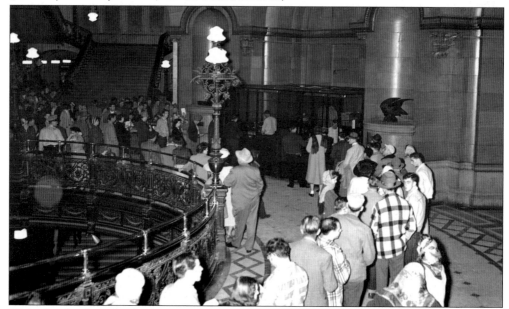

With the deadline for displaying new license plates fast approaching, the secretary of state's office is inundated with drivers purchasing plates at a counter located on the second floor on January 28, 1958. (Courtesy Secretary of State, Illinois State Archives.)

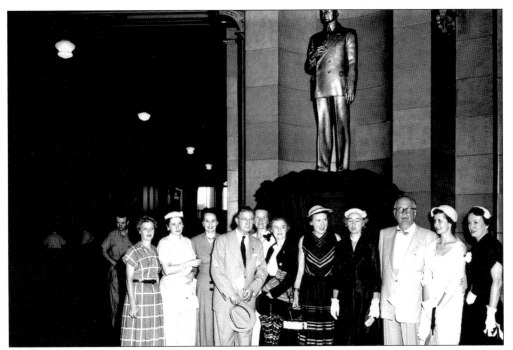

On June 26, 1953, a statue of Richard J. Barr was dedicated in the second-floor rotunda. Elgin resident and sculptor Trygve Rovelstad was commissioned for the work. Barr served in the Illinois Senate for 48 years. (Courtesy Secretary of State, Illinois State Archives.)

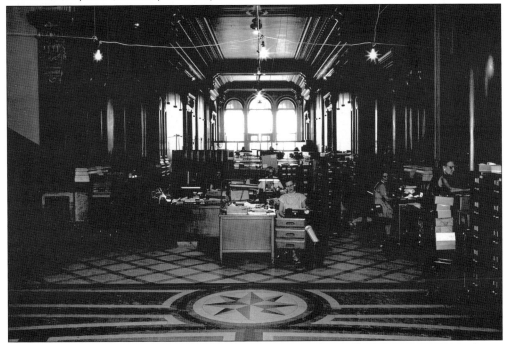

The south corridor of the second floor, now known as the Hall of Governors, served as a makeshift office before the Automobile Department completed a move in October 1956. (Courtesy Secretary of State, Illinois State Archives.)

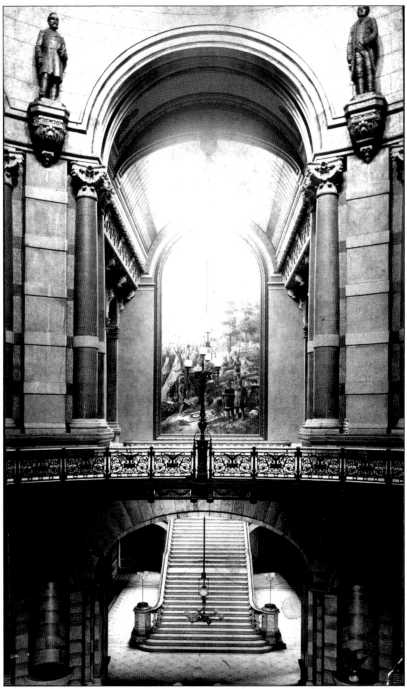

In April 1877, William H. Bell from Rochelle presented a sculpture of a bald eagle to Gov. Shelby Cullom. The eagle may be seen in a second-floor rotunda alcove (lower right) and stood in the statehouse until 1986. It was then replaced by a statue of the first African American state senator, Adelbert Roberts. The eagle was discovered in storage in 2001, has since been refurbished, and is due to be rededicated in a place of prominence in the statehouse. The restored eagle can be seen on the facing page. (Courtesy Abraham Lincoln Presidential Library.)

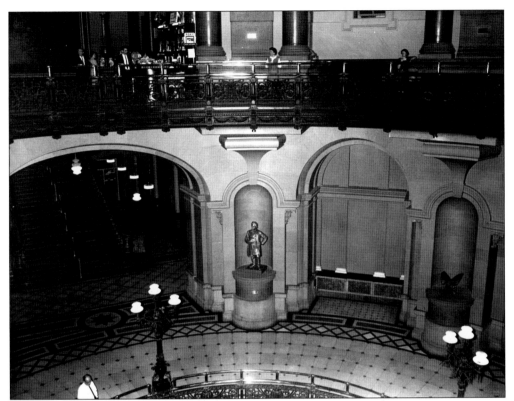

Statues of Stephen A. Douglas and an American eagle stand guard in the second-floor rotunda on January 24, 1962, while the third floor is busy with people shopping at a snack stand. (Courtesy Secretary of State, Illinois State Archives.)

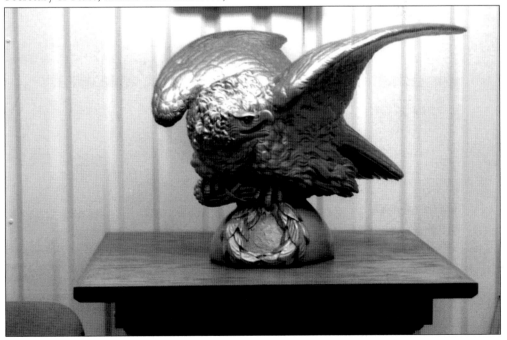

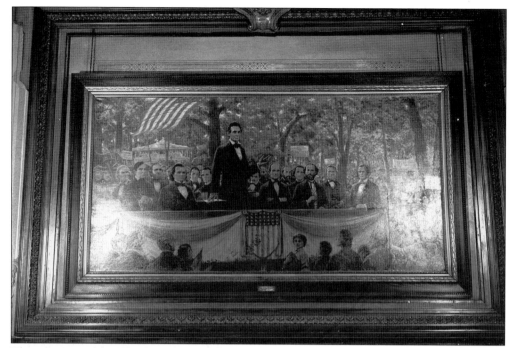

This painting of the Charleston Lincoln-Douglas debate has hung in the statehouse since 1918. It is one of several paintings in the building by Shelbyville artist Robert Root. In 2009, the painting hangs in the governor's office. As seen in this photograph, the painting was displayed in the north corridor of the second floor for many years. (Courtesy Secretary of State, Illinois State Archives.)

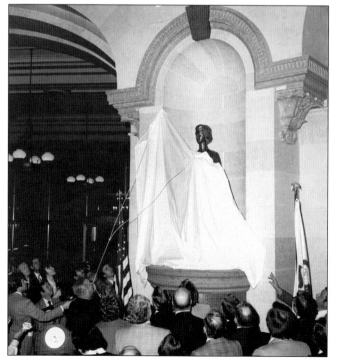

The second-floor statue of Lottie Holman O'Neill, Illinois' first female legislator, was dedicated on January 14, 1976. Representative O'Neill moved to the senate when she was elected to fill the seat of the retiring Richard J. Barr, whose statue is located across the corridor. (Courtesy Secretary of State, Illinois State Archives.)

As the architects originally designed, one would enter the statehouse on the second floor focusing on the magnificent marble grand staircase. The barrel-vaulted ceiling over the stairs creates a breathtaking view of the upper rotunda and dome. (Courtesy Abraham Lincoln Presidential Library.)

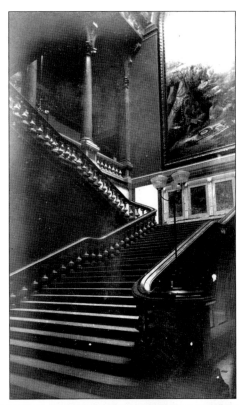

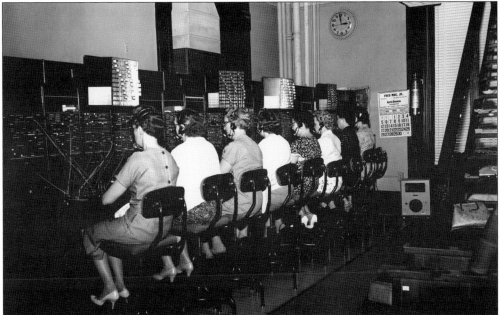

Telephone lines connecting the governor's office at the statehouse to the Illinois Executive Mansion, and the statehouse to the Western Union telegraph office, were constructed in 1878. In 1960, state operators had to deal with many more connections in the switchboard room. (Courtesy Secretary of State, Illinois State Archives.)

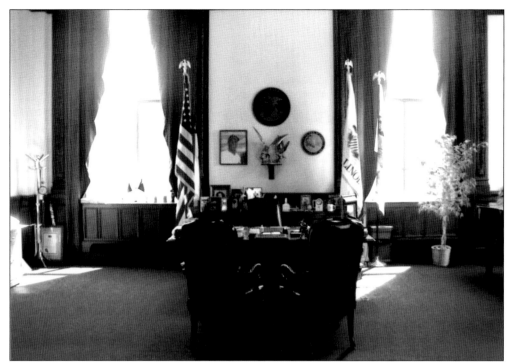

Here is a 2004 view of Secretary of State Jesse White's office. Although not always at this location, the secretary's personal office has been located on the executive floor since this level was first occupied.

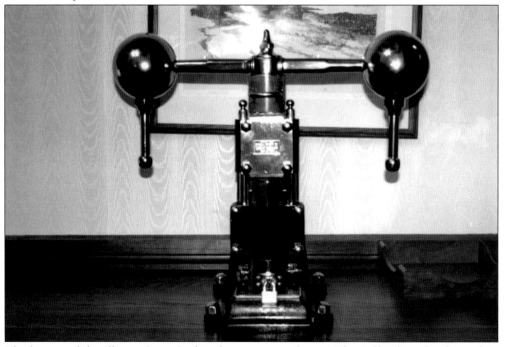

The keeper of the Illinois State Seal is the secretary of state. The "official" seal is housed in Room 213.

Four

THIRD AND FOURTH FLOORS

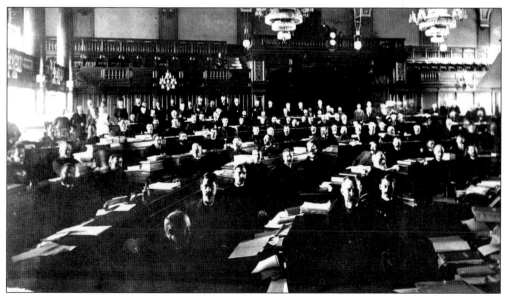

The Illinois legislature first convened in the current statehouse in 1877. This 1887 view of the Illinois House of Representatives was taken from the Republican (west) side of the house chamber. (Courtesy Abraham Lincoln Presidential Library.)

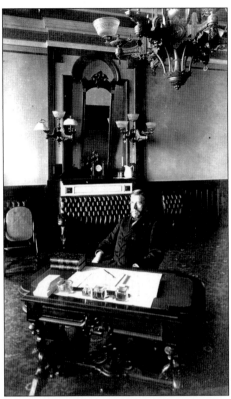

Lt. Gov. John C. Smith (1885–1889) is seated at the desk in his office directly behind the senate chamber. This room is presently occupied by the senate president. (Courtesy Abraham Lincoln Presidential Library.)

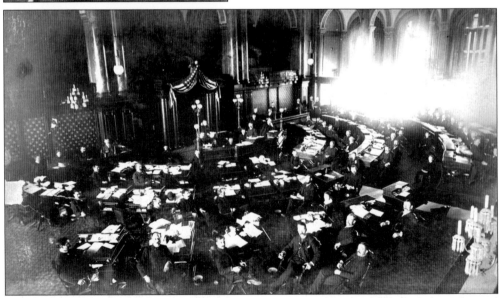

In 1887, the Illinois Senate consisted of 51 members. Among the items at the members' disposal were spittoons placed throughout the chamber. An 1877 *Illinois State Journal* article states that two janitors were employed just to attend to the 346 cuspidors located in the statehouse. The pay for keeping these "receptacles of filth" clean was only $2 per day. The opaque glass and wooden walls visible in the background separate the chamber from the outer halls. The glass and walls have recently been restored. (Courtesy of Abraham Lincoln Presidential Library.)

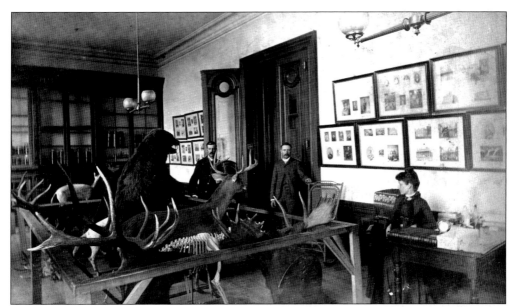

The Illinois State Museum was founded in 1877, and its first home was located here in the statehouse. The museum was originally a natural history museum and included many exhibits of plants, animals, and minerals. This large room now houses senate offices. (Courtesy Abraham Lincoln Presidential Library.)

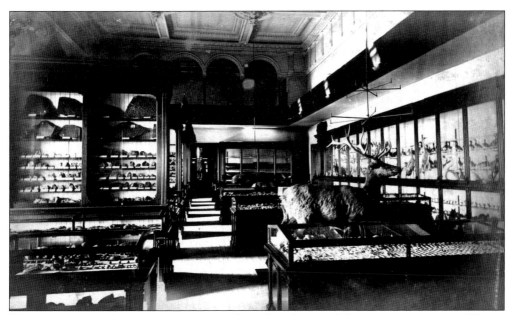

This image was taken just prior to a geological and natural history museum (now Illinois State Museum) vacating today's Room 309. The museum moved to make room for the Illinois State Library. The architects originally envisioned the space as a home for the library, which was located here until it was moved to the Centennial (now Howlett) Building in the 1920s. (Courtesy Abraham Lincoln Presidential Library.)

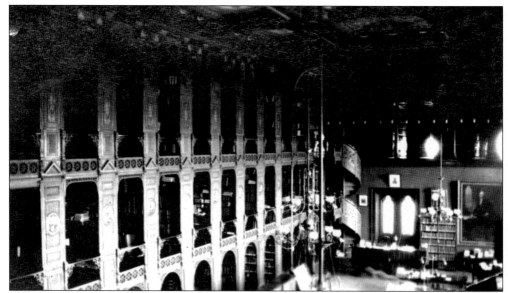

The Illinois State Library was housed in what is now Room 309. Visitors enjoyed this ornately decorated facility until the library was moved to the new Centennial (now Howlett) Building. Although Abraham Lincoln never stepped foot in the new statehouse, the library displayed a painting of George Washington that hung in Representatives Hall in Springfield's Old State Capitol during his tenure there. It is visible in the lower right of this photograph. (Courtesy Abraham Lincoln Presidential Library.)

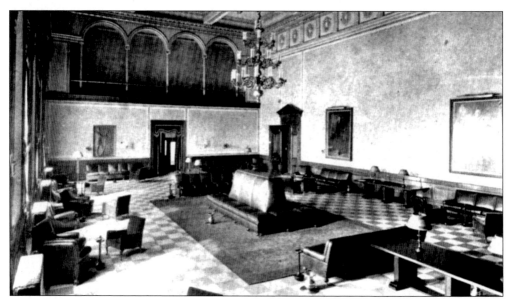

Room 309 was utilized as a reception area in the early 1920s and again in the 1950s. The paintings of George Washington and the Marquis de Lafayette are clearly on display as well as a bronze relief commemorating the Illinois Rangers in the War of 1812. Today the paintings are located in the Old State Capitol in Springfield, and the relief may be found on the first floor of the Centennial (now Howlett) Building. (Courtesy Secretary of State, Illinois State Archives.)

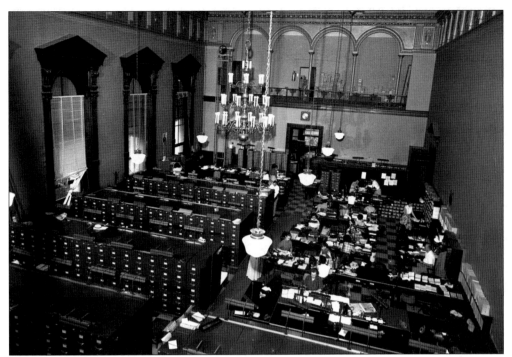

In August 1954, today's Room 309 was occupied by a division of the secretary of state. It is occupied today by offices of the Illinois Senate. (Courtesy Secretary of State, Illinois State Archives.)

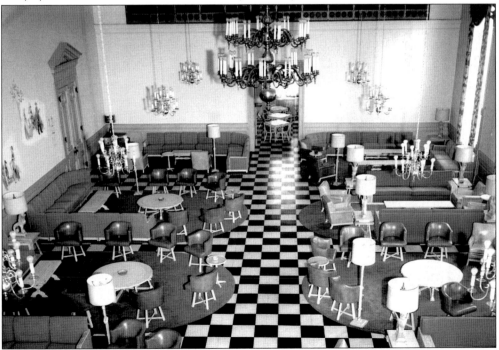

Furnished with period decor in 1961, the Room 309 lounge provided legislators with a place to wind down. Remnants of the old Illinois State Library may still be seen in the balcony level. (Courtesy Secretary of State, Illinois State Archives.)

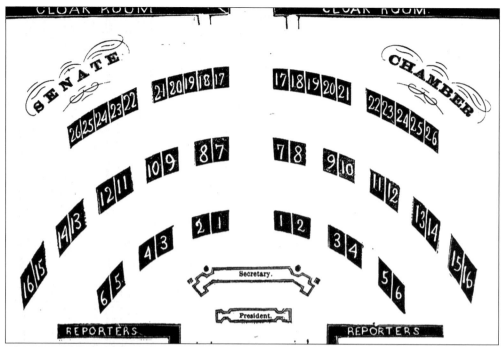
This seating chart for the Illinois Senate dates to an 1877 legislative manual.

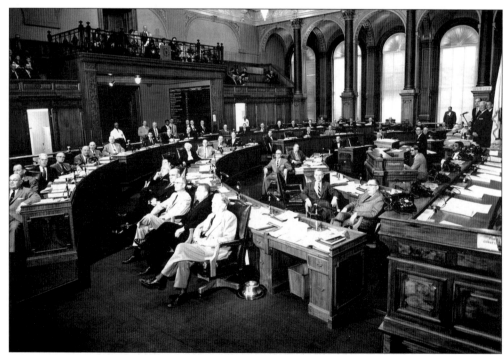
As seen from the Republican (east) side of the chamber, the senate stands at ease on March 19, 1957. At this time there are no partitions between the chamber and the corridors on the east and west sides of the room, only brass rails. This accounted for the phrase "voting within bar." (Courtesy Secretary of State, Illinois State Archives.)

Colored-glass lay lights were installed in the house and senate ceilings to aid in lighting the chambers. The art glass in both rooms was removed during the 20th century and was recently restored in the house chamber.

During the 2006 renovation of the senate chamber, it was determined that it was not possible to replace the lay light. Regardless of this, the chamber now exhibits much of its early beauty.

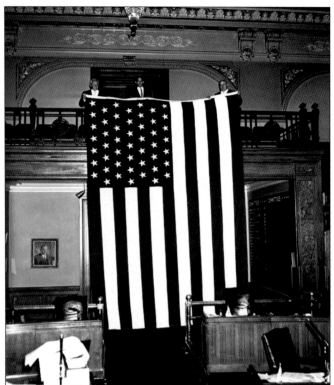

Alaska officially became a state on January 3, 1959. Here the new 49-star U.S. flag is on display in the Illinois Senate on July 1, 1959. (Courtesy Secretary of State, Illinois State Archives.)

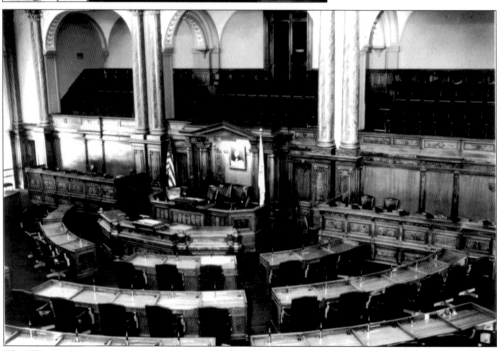

The Illinois Senate is pictured here in 1969. In 1932, portraits of George Washington were hung in the legislative chambers to commemorate the bicentennial of his birth. (Courtesy Secretary of State, Illinois State Archives.)

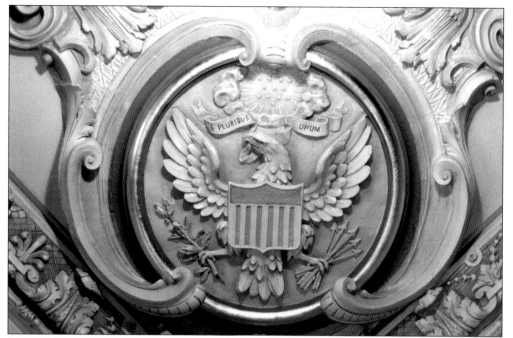

Located in opposite corners of the ceiling of the senate chamber are plaster representations of the Great Seal of the United States. First publicly used in 1782, the seal has appeared on the back of a $1 bill since 1935. In addition, the senate ceiling also contains reliefs of the Illinois State Seal.

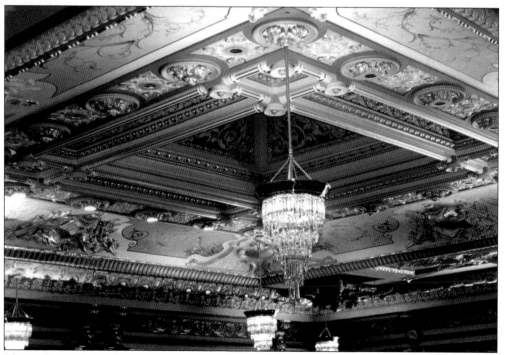

The ceilings of the Illinois House and Senate chambers were restored during 2000 and 2001. Seen here is a close-up of one of the 12 chandeliers located in the senate chamber.

The senate and house chambers underwent an extensive restoration during the early 1970s. Each chamber's podium, desks, flooring, and woodwork were refurbished or completely replaced. (Courtesy Secretary of State, Illinois State Archives.)

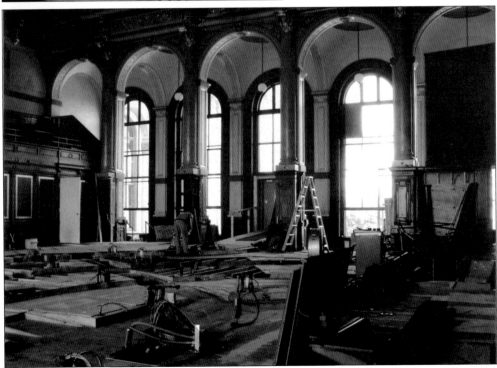

On June 23, 2006, workers are in the process of stripping down the senate floor during renovation of the chamber.

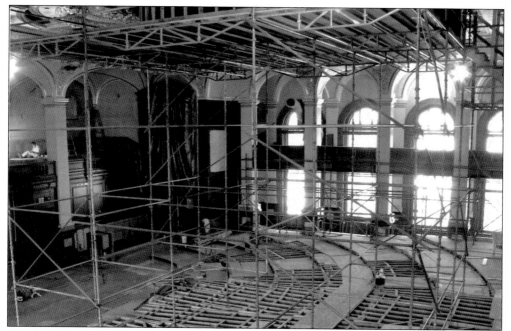

The legislative chambers were renovated in 1974, but since that time many structural and functional problems developed. It was decided that it was necessary to completely overhaul each chamber. On July 7, 2006, the house members' desks have been removed, scaffolding is erected, and work is well underway.

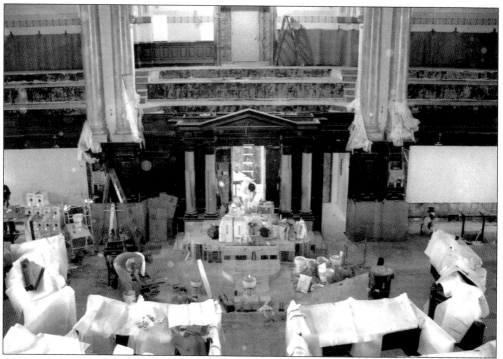

Although the senate podium has not yet been installed, the members' desks have been replaced in this 2006 view.

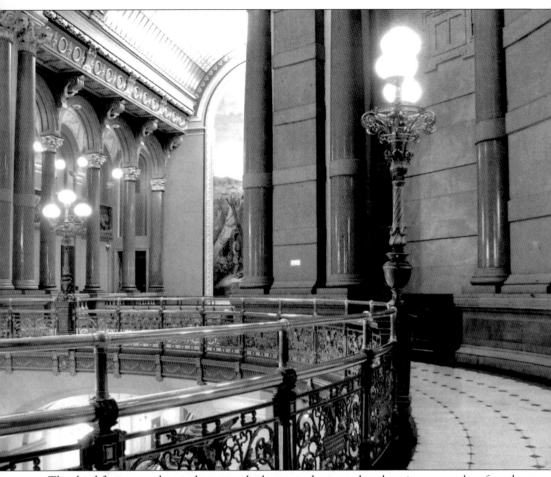

The third-floor rotunda area between the house and senate chambers is commonly referred to as "the Rail." Over the years, this location has been a favorite gathering place of groups, including legislators and lobbyists. The Rail, as seen here in 2006, provides people a place to share their opinions of pending legislation or to just pause and take in the sights and sounds of another hectic legislative session.

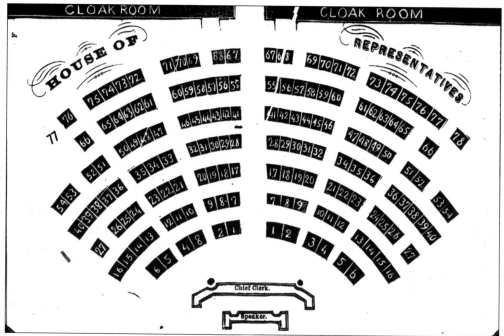

This seating chart for the Illinois House of Representatives dates to an 1877 legislative manual.

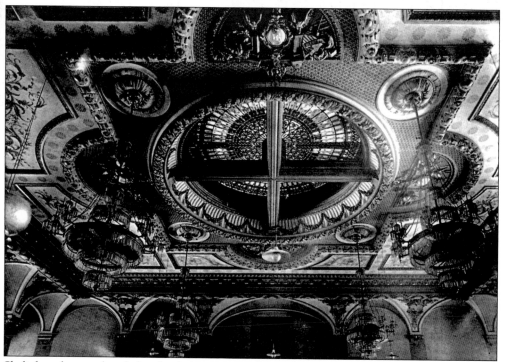

Skylights above colored-glass lay lights were used to aid in the illumination of both legislative chambers until sometime in the early or mid-20th century. This view depicts the lay light in the house chamber, which was recently restored. (Courtesy Sangamon Valley Collection, Lincoln Library.)

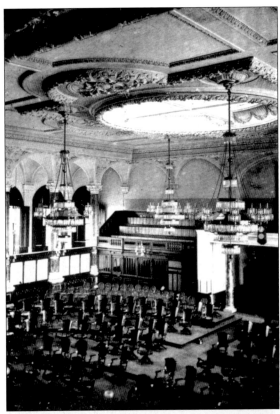

In 1877, the ceiling in the house was not yet completed, and for the first decade of the chamber's use, there were no east and west galleries. The rolltop desks are not seen in the chamber—only chairs are visible. It appears the colored-glass lay light in the ceiling has not yet been installed. (Courtesy Images in Time Collection, Toledo-Lucas County Public Library.)

The term "voting within bar" is visually demonstrated when viewing the configuration of the senate chamber in 1944. (Courtesy Secretary of State, Illinois State Archives.)

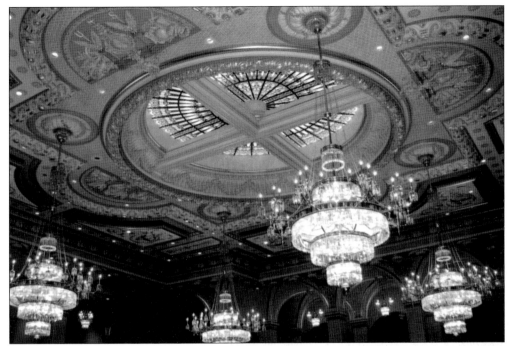

After a 1933 fire that began on the sixth floor of the south wing, the original chandeliers in the house chamber were altered dramatically. Each fixture was recently removed, and an extensive effort was made to restore each to its original appearance.

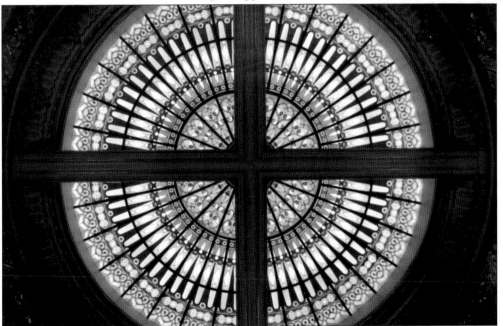

In 2006, both the house and senate chambers underwent extensive restorations to bring them back to their early-20th-century appearances. To re-create the colored-glass lay light for the house chamber, experts studied photographs and visited the Iowa Statehouse, which was also designed by Illinois Statehouse architects John Cochrane and Alfred Piquenard.

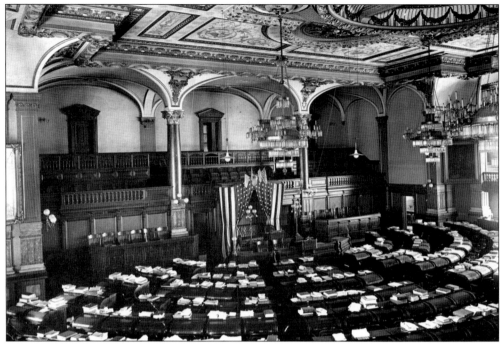

Observe the old rolltop desks in the Illinois House of Representatives. United States flags were once draped on either side of the speaker's chair.

In 1933, fire raged throughout the fifth and sixth floors of the house wing. Damage was estimated at $100,000, a large sum at that time, and the origin of the fire is still unknown. Here water can be seen cascading from the capitals of the columns in the chamber. (Courtesy Abraham Lincoln Presidential Library.)

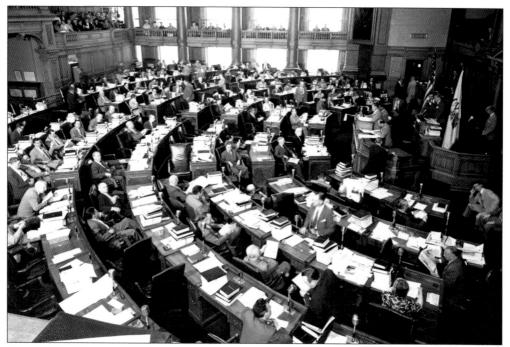

A typical session day for the Illinois House of Representatives in 1949 included cumbersome bill books and other printed materials crowding members' desks. Also adding to the congestion in 1949, the house chamber was populated by 59 more members than today. (Courtesy Secretary of State, Illinois State Archives.)

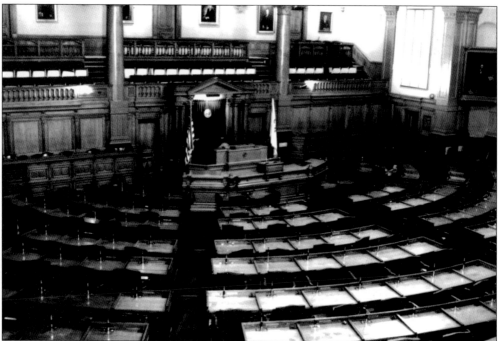

Here is the Illinois House of Representatives as seen in 1969. (Courtesy Secretary of State, Illinois State Archives.)

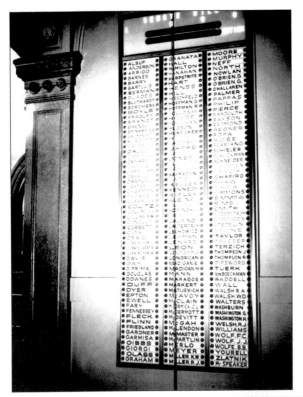

Electronic voting by members began in 1951. The voting board seen here in 1971 records the membership of the 77th Illinois General Assembly. A 1980 amendment to the Illinois Constitution cut the size of the Illinois House of Representatives from 177 to 118 members. (Courtesy Secretary of State, Illinois State Archives.)

During the 2006 restoration of the house chamber, an old chalkboard for posting committee schedules was uncovered. In addition to the daily calendars printed for both legislative bodies, committee information is now available electronically on monitors located near the legislative chambers as well as on the Illinois General Assembly's Web site.

The head of the grand staircase is seen around 1877. There are two bas-reliefs on either side of this area: the north sculpture, seen here, portraying the displacement of Native Americans, and the south sculpture, depicting the incoming settlers moving west. (Courtesy Images in Time Collection, Toledo-Lucas County Public Library.)

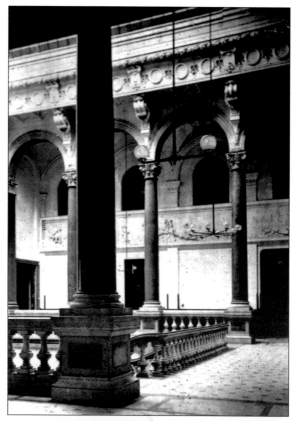

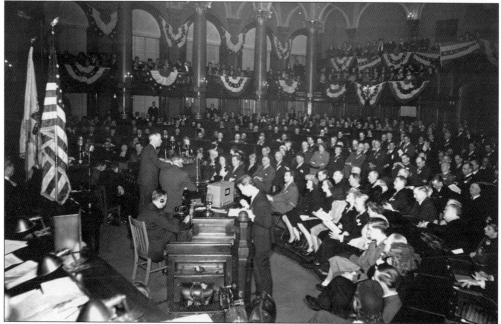

Gov. Dwight Green (1941–1949) speaks to a crowded and decorated house chamber during the 1945 inaugural ceremonies. (Courtesy Secretary of State, Illinois State Archives.)

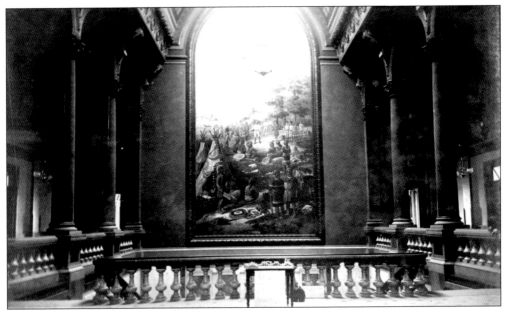

Gustav Fuchs painted this 20-by-40-foot mural directly on the wall beginning in January 1886. Work was suspended in April due to questions about the locale featured in the painting. Once work resumed, the painting was completed in late September or early October of the same year. Much later, it was discovered that the Native American culture portrayed was never found in Illinois. Fuchs was paid $2,500 for his efforts. This artwork is considered priceless despite the misrepresentations. (Courtesy Abraham Lincoln Presidential Library.)

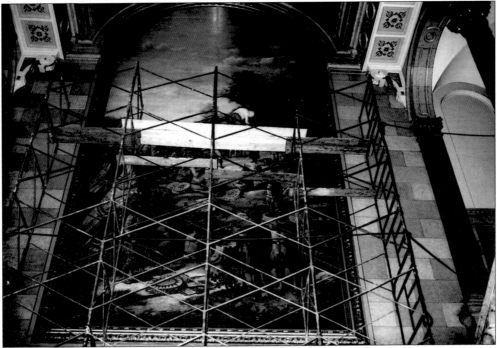

The Fuchs mural is being restored in August 1953. Notice that the walls adjacent to the mural have been painted to resemble stone. (Courtesy Secretary of State, Illinois State Archives.)

Cleaning Fuchs's George Rogers Clark mural occurred in the spring of 2001. Clark, older brother to William of Lewis and Clark fame, led the American militia during the Revolutionary War to capture key British forts in the Illinois Country.

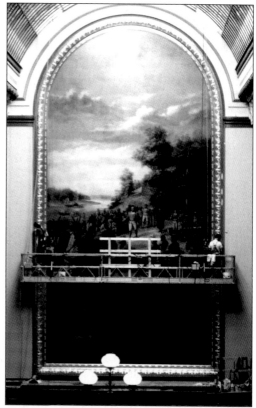

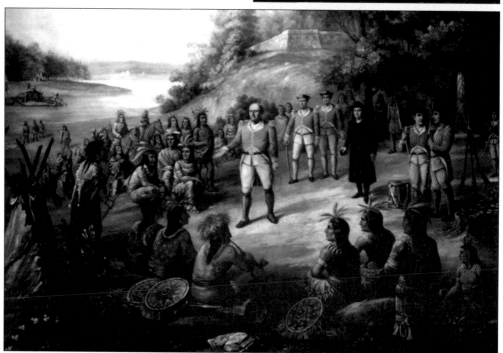

Here is a close-up of the Gustav Fuchs painting taken after the 2001 cleaning.

The fourth-floor transom windows above the entrances to the house and senate galleries were brought back to a c. 1900 appearance during the 2006 renovation. Both galleries are open to the public and provide visitors an overhead view of the daily work of the Illinois General Assembly.

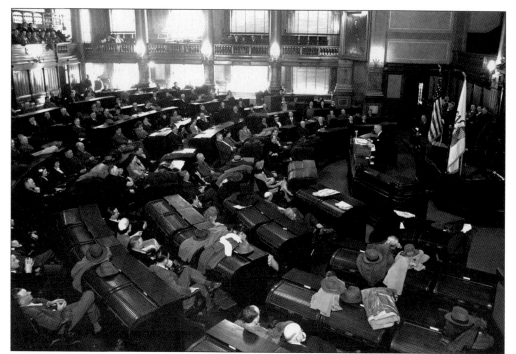

Gov. Dwight Green (1941–1949) speaks to a veterans group in the house chamber on December 14, 1945. The gallery visible in front of the windows was not an original feature of the Hall of Representatives. The east and west galleries were constructed between 1886 and 1887. (Courtesy Secretary of State, Illinois State Archives.)

Seen here on March 22, 2004, Committee Room 400 had gone through an extensive restoration when the walls and ceiling were returned to their 1884 appearance. In that year, the room was part of a larger area encompassing the state's Civil War memorabilia.

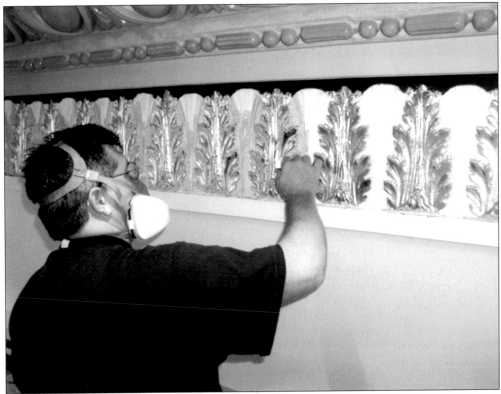

During the winter of 2003–2004, the ceiling in Senate Hearing Room 400 underwent a restoration. Here golf leaf is being applied to plaster cornice ornamentation.

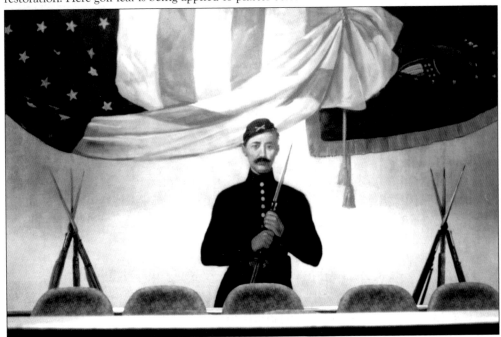

A mural of a Union soldier is located on the west wall of Room 400.

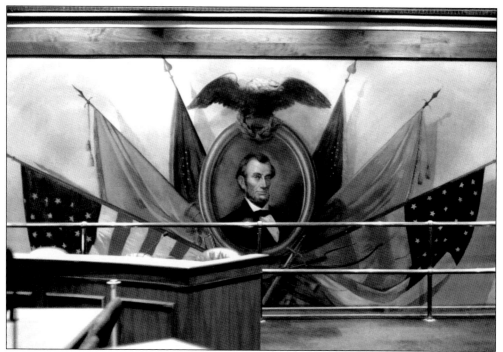

Abraham Lincoln is depicted in a mural on the south wall of Room 400. He served as commander-in-chief of the Union forces during the Civil War. St. Louis, Missouri, fresco painter Ettore S. Miragoli was responsible for the decoration of Memorial Hall. The Italian-born Miragoli had earlier done work on the governor's office and the supreme court chambers.

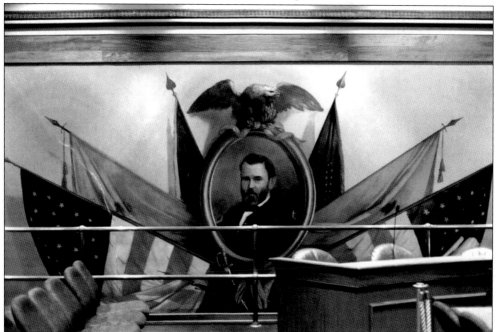

In Room 400, Gen. Ulysses S. Grant graces a north wall mural. Lincoln appointed Grant general-in-chief of the Union army in March 1864.

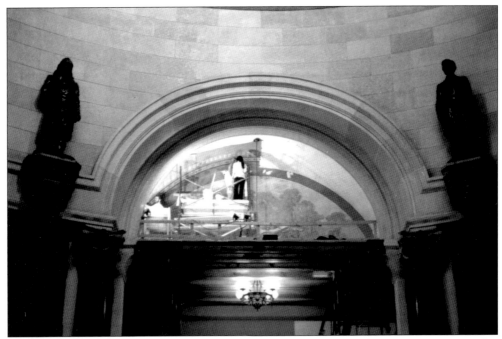

In 2001, the fourth-floor vaulted ceilings were restored to their original appearance. During this same period, the three fourth-floor murals representing commerce, agriculture, and industry were also refurbished.

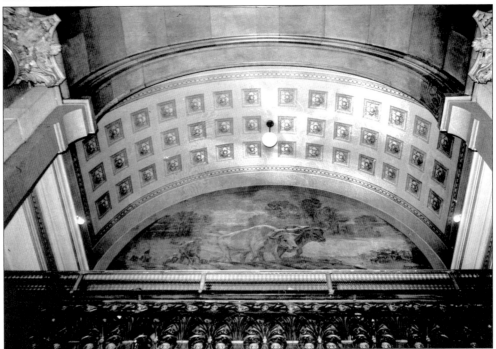

This represents one of the two styles of decoration for the ceilings above the fourth-floor murals. This version was replaced in 2001 with the earlier style. The wall painting representing agriculture was added in 1918. (Courtesy Secretary of State, Illinois State Archives.)

Five

DOME

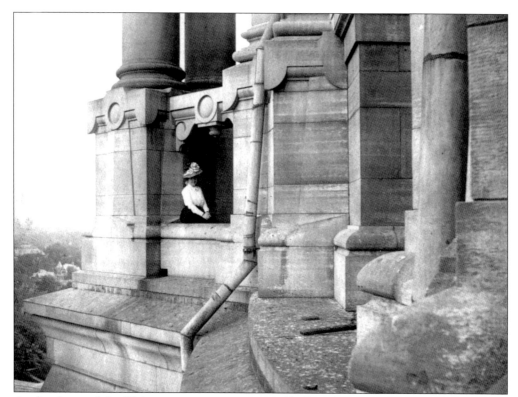

At the dawn of the 20th century, visitors were still allowed to tour the upper dome, which was closed to the general public in the 1930s. (Courtesy Sangamon Valley Collection, Lincoln Library.)

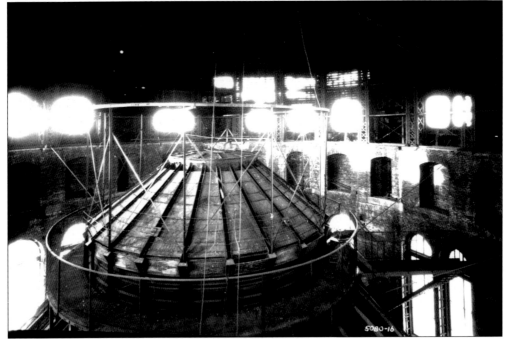

Natural light and gas jets illuminated the stained glass at the top of the rotunda before the glasswork was enclosed for protection. Daylight may be seen through the damaged outer dome as well. (Courtesy Abraham Lincoln Presidential Library.)

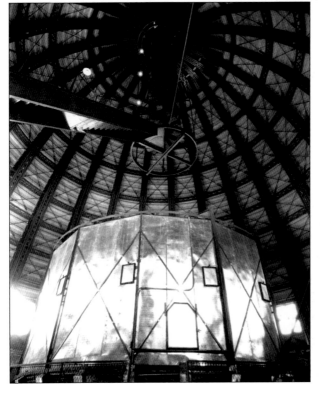

During the 1932 restoration of the dome, this enclosure was constructed around the stained glass at the apex of the inner dome. A spiral staircase is suspended directly above the glasswork and leads to the uppermost observation deck and flagpole at the top of the outer dome. (Courtesy Abraham Lincoln Presidential Library.)

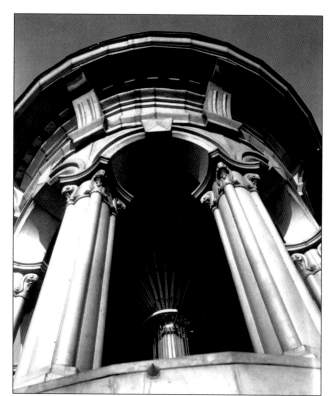

Still downstate's tallest building, the statehouse can be seen from miles around. These images illustrate some of the various lighting devices used as beacons atop the dome. (Courtesy Abraham Lincoln Presidential Library.)

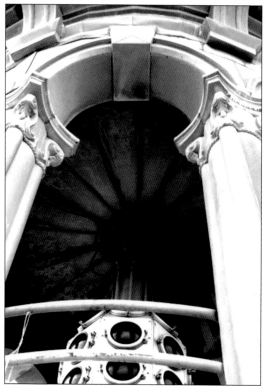

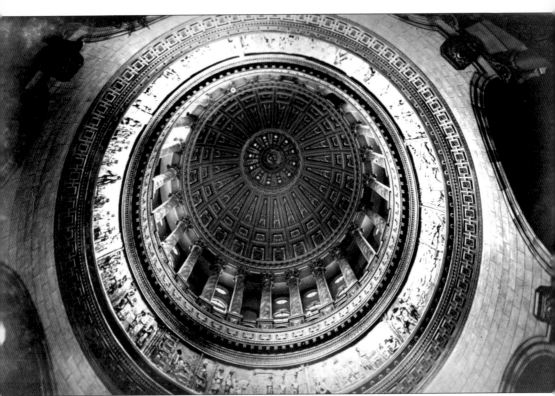

No statues are present in this 1887 view of the dome. The statues to be placed on these empty platforms (seen in the corners of the image) were the subject of controversy from 1886 to 1888. A lawsuit was filed to block the statehouse commissioners from naming the "Big Eight" Illinoisans to be honored on the pedestals. The commissioners were not deterred, and statues of John A. Logan, William R. Morrison, Ninian W. Edwards, Shadrach Bond, Edward Coles, Sydney Breese, Lyman Trumball, and Ulysses S. Grant were placed. These works were unveiled in the autumn of 1887. (Courtesy Abraham Lincoln Presidential Library.)

On September 13, 1911, Springfield was struck with severe weather. The windstorm broke many of the statehouse's windows and damaged the southwest (pictured) and northeast sides of the dome. Debris, including copper sheathing from the dome, was strewn about the capitol grounds. (Courtesy Abraham Lincoln Presidential Library.)

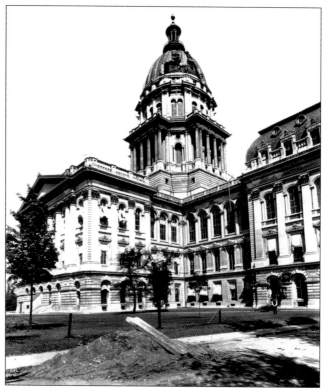

The dome has been repaired numerous times. Men can be seen here working on the dome's south side. (Courtesy Abraham Lincoln Presidential Library.)

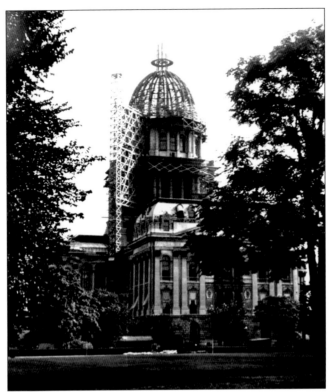

In 1932, the dome underwent a massive reconstruction to correct age-related deterioration. Scaffolding was erected on the dome's southwest side to provide workers access to the heights. (Courtesy Illinois Secretary of State, Physical Services.)

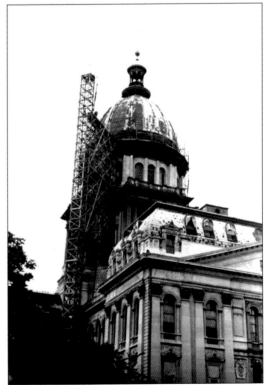

Time and weather have taken their toll, as can easily be seen in this image. (Courtesy Abraham Lincoln Presidential Library.)

By October 1932, the lantern deck and globe at the base of the flagpole began to take shape. (Courtesy Illinois Secretary of State, Physical Services.)

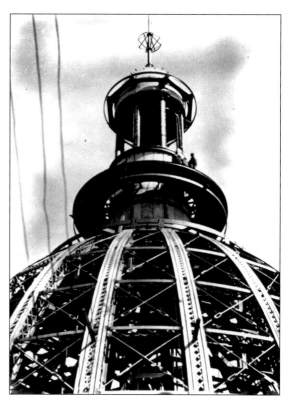

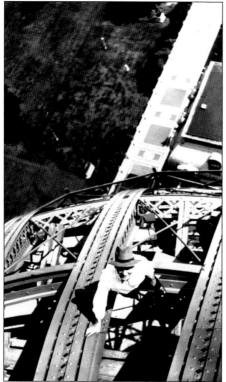

On July 14, 1932, the dome's shell had been removed, and the inner framework was exposed to the elements. Workers were charged with the complete overhaul of this upper structure. (Courtesy Illinois Secretary of State, Physical Services.)

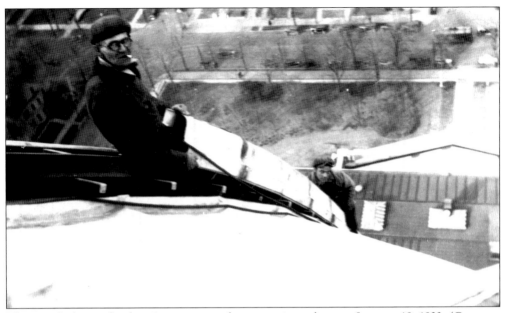

The raised ribs on the dome's exterior are being put into place on January 19, 1933. (Courtesy Illinois Secretary of State, Physical Services.)

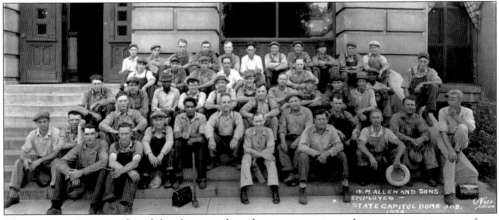

The construction crew hired for the complete dome renovation takes a moment to pose for a photograph on the west steps in 1932. (Courtesy Secretary of State, Illinois State Archives.)

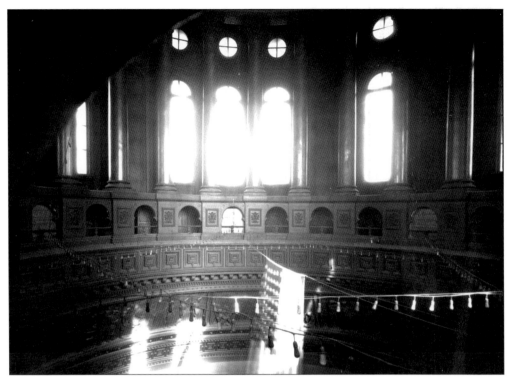

This interesting image shows a United States flag and lights strung across the colonnade level of the upper dome. (Courtesy Abraham Lincoln Presidential Library.)

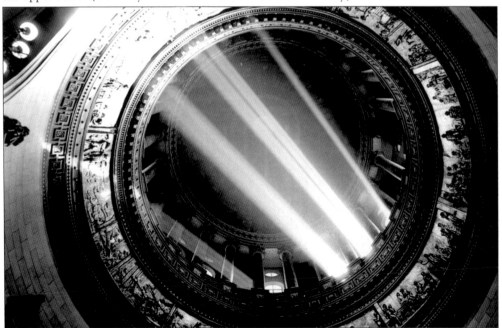

This photograph was taken on February 5, 1947. Sunlight streams through the upper dome in this excellent work by longtime state photographer Eddie Winfred "Doc" Helm. (Courtesy Secretary of State, Illinois State Archives.)

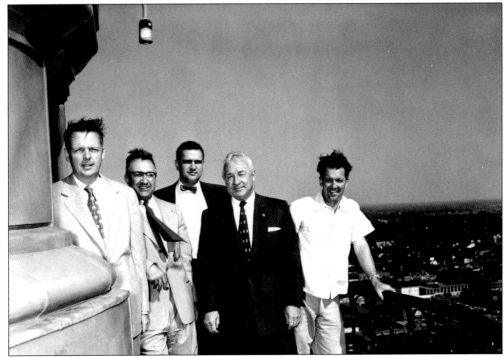

Gov. William G. Stratton (1953–1961), seen at left, and Secretary of State Charles F. Carpentier (1953–1964), seen second from right, stop for a photograph atop the statehouse on September 30, 1953. (Courtesy Secretary of State, Illinois State Archives.)

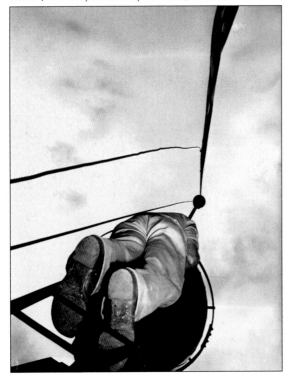

The United States and Illinois state flags are flown over the statehouse. Although presently there is no set rule regarding the frequency for changing the flags, they are replaced upon showing wear and tear every few weeks. Upon proclamation by the governor, the flags are flown at half-staff for fallen Illinois military personnel, police officers, firefighters, or dignitaries, and the flags are then given to the family. As seen here, a worker is climbing the ladder without the luxury of the "cage" that surrounds it today. A four-foot trapdoor opens to the exterior ladder that leads to the base of the statehouse flagpole. (Courtesy of Secretary of State, Illinois State Archives.)

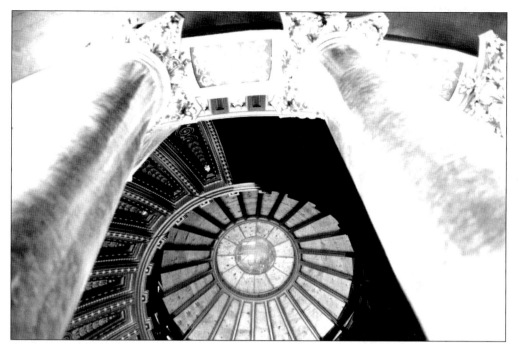

During the 1986 dome restoration, scaffolding was erected from the first floor to the upper rotunda. The stained-glass representation of the state seal was replaced with plywood while it was cleaned and repaired.

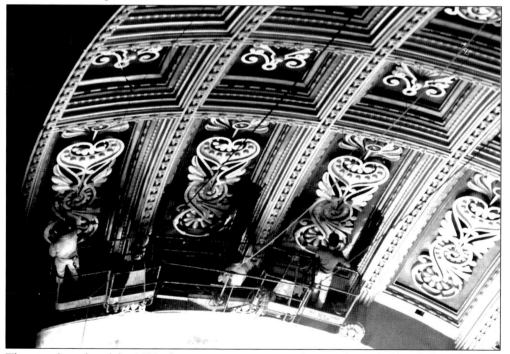

The visual results of the 1980s dome restoration were striking. What was once dark and hard to see returned to its original glory. This work culminated in 1988, the centennial of the completion of the building.

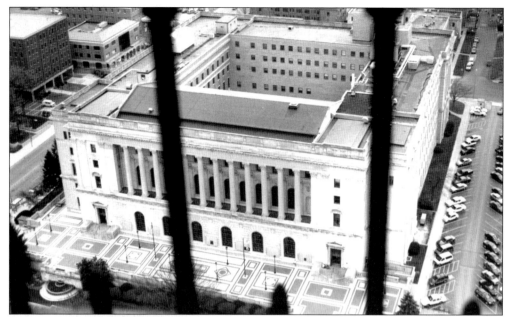

From the observation deck atop the statehouse dome, the open area within the Centennial (now Howlett) Building can be viewed in this 2001 image.

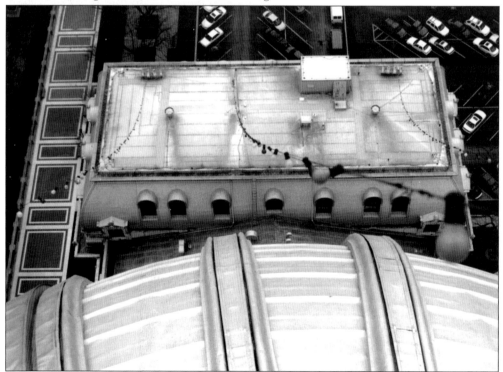

Christmas lights strung from the base of the observation deck hang above the roof of the south wing. The lights can be seen for miles on a clear evening. Electricians string these bulbs in late fall when the weather is still somewhat warm, although they are not illuminated until after Thanksgiving.

The Old State Capitol is framed by the railing atop the dome in this 2001 scene of downtown Springfield.

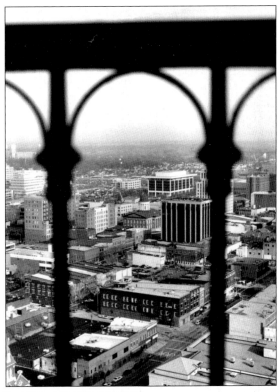

Since 1876, the United States flag has flown at the top of the dome—approximately 405 feet above the ground. This scene catches a glimpse of Old Glory taken from the observation deck.

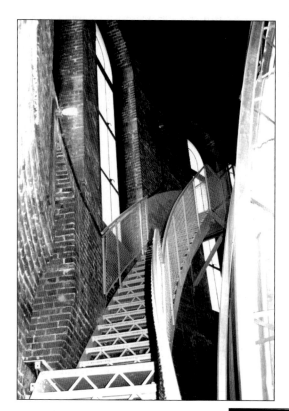

The outer dome is constructed mostly of brick and stone, while the inner dome's shell is of metal. This stairway winds its way between the two structures.

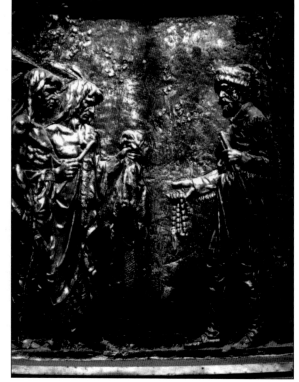

At the base of the dome are bas-relief plaster panels depicting historic scenes such as the Lincoln-Douglas debates and a settler trading with Native Americans, as seen here. Some say this frieze is the best work of art in the building.

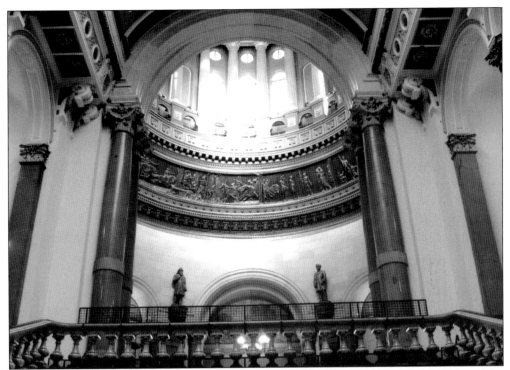

The mezzanine level of the grand staircase allows one to fully appreciate the grandeur of the inner dome, as seen on March 22, 2004.

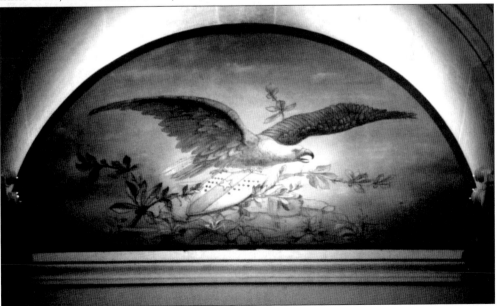

The four eagle murals below the corbels in the upper rotunda were painted by Springfield artist George H. Schanbacher in 1918. This artwork was among several changes made to the building in honor of Illinois' centennial. The 10 stars on each side of the shield represent the states of the North and South. Illinois, the 21st state admitted to the union, is symbolized by the large star on the ribbon that runs down the center of the shield.

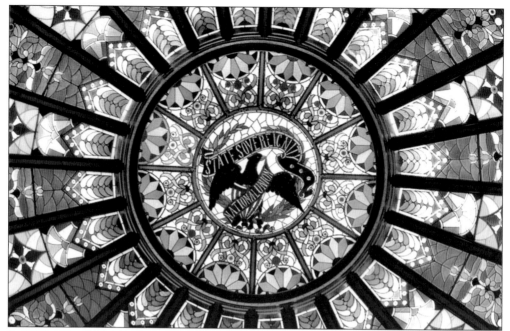

In 1987, when the stained glass atop the inner dome was removed during the restoration, it was discovered that the word *sovereignity* in the state seal was "misspelled." This spelling of the word *sovereignty* with the extra *i* was once an accepted variation.

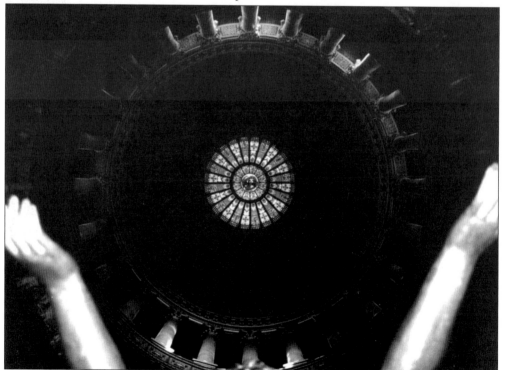

The oculus (eye of the dome) is seen through the outstretched arms of the *Illinois Welcoming the World* statue.

Six

GROUNDS AND EXTERIOR

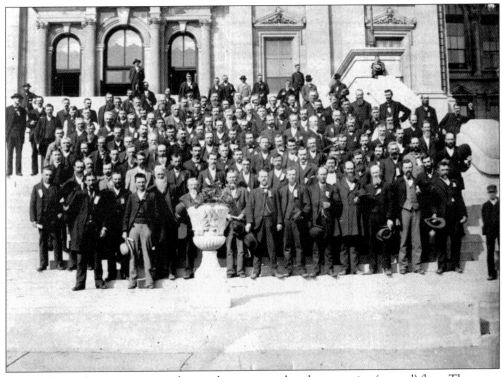

Originally, the front entrance to the statehouse opened to the executive (second) floor. The stone staircase leading to this entrance was removed in October 1885. One man was killed and several workers were injured in an accident during the removal of these steps. This photograph, shot during the commissioners of highways convention on September 24, 1884, is the only known close-up photograph of the original stairs. (Courtesy Abraham Lincoln Presidential Library.)

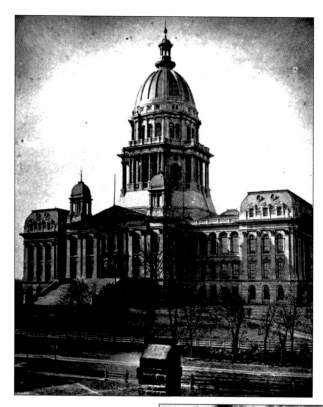

This crisp image of the northeast side of the statehouse was included in a book of photographs published by the Wabash Railroad, depicting attractions along the railway. (Courtesy Images in Time Collection, Toledo-Lucas County Public Library.)

During the 1868 redesign of the Illinois State Seal, there was some debate as to which phrase—*national union* or *state sovereignty*—would have prominence. As seen here on the east facade of the statehouse, a banner was hung with both phrases, possibly for the visit of Pres. Rutherford B. Hayes on September 30, 1879. (Courtesy Abraham Lincoln Presidential Library.)

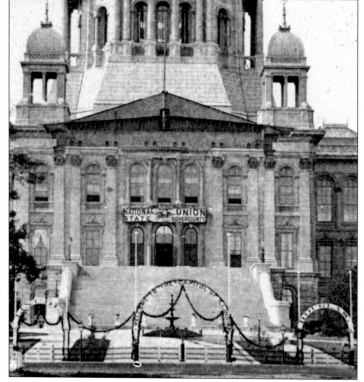

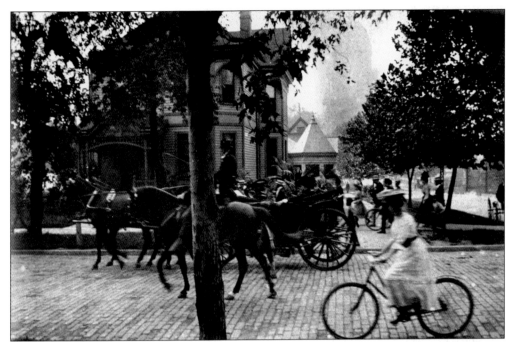

Vice Pres. Theodore Roosevelt visited Springfield on August 30, 1901. He came to inspect Illinois National Guard troops at Camp Lincoln at the invitation of their commander-in-chief, Gov. Richard Yates (1901–1905). The statehouse may be seen in the distance as Yates and Roosevelt ride in a carriage possibly headed for the Illinois Executive Mansion. (Courtesy Sangamon Valley Collection, Lincoln Library.)

Charles Street ran east–west immediately south of the statehouse. This one-block stretch was removed in the early 1920s when the capitol complex expanded southward.

During the early part of the 20th century, the capitol complex began to take shape. The Illinois Statehouse, castlelike Illinois State Arsenal, and powerhouse are seen in this image. The arsenal

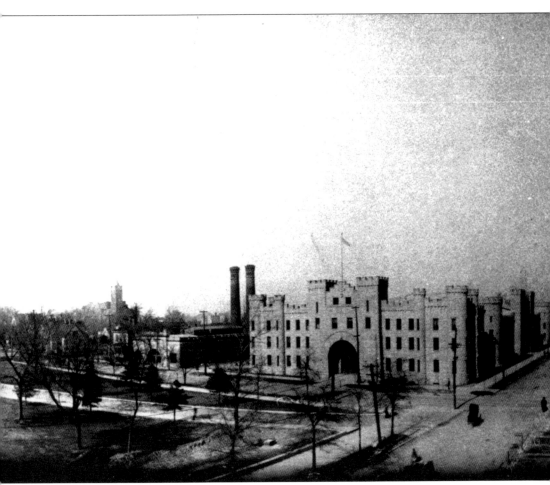

burned in a spectacular blaze in 1932 and was replaced by the current Illinois State Armory. (Courtesy Abraham Lincoln Presidential Library.)

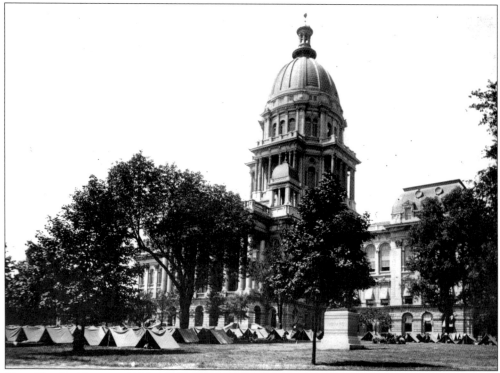

Gov. Charles Deneen (1905–1913) called upon the Illinois National Guard to bring order to the city during a race riot that occurred in Springfield in August 1908. Many of the guardsmen camped on the statehouse grounds. The Springfield riot was a pivotal event that led to the formation of the National Association for the Advancement of Colored People (NAACP). (Courtesy Abraham Lincoln Presidential Library.)

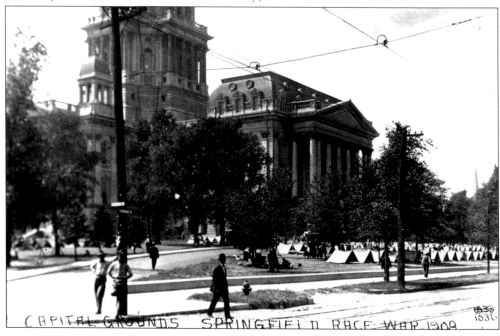

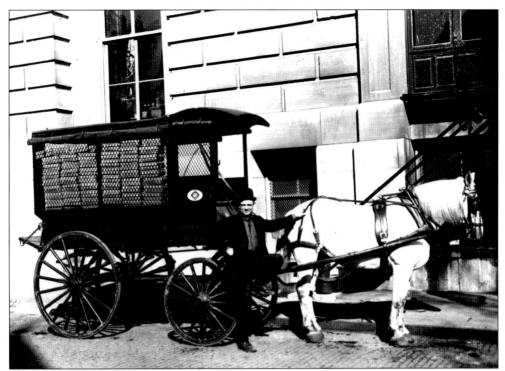

Wagons, like those of the Adams Express Company and the famed Wells Fargo and Company, once were used to deliver goods of all kinds in cities across the nation, as seen here at the Charles Street entrance to the statehouse. (Courtesy Abraham Lincoln Presidential Library.)

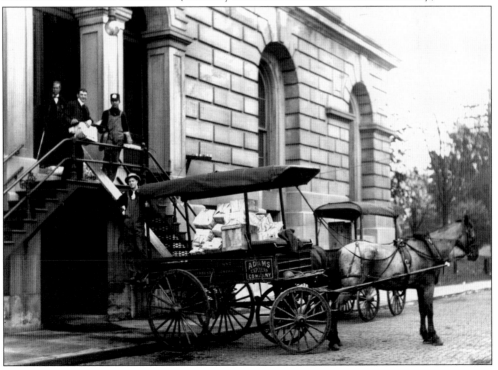

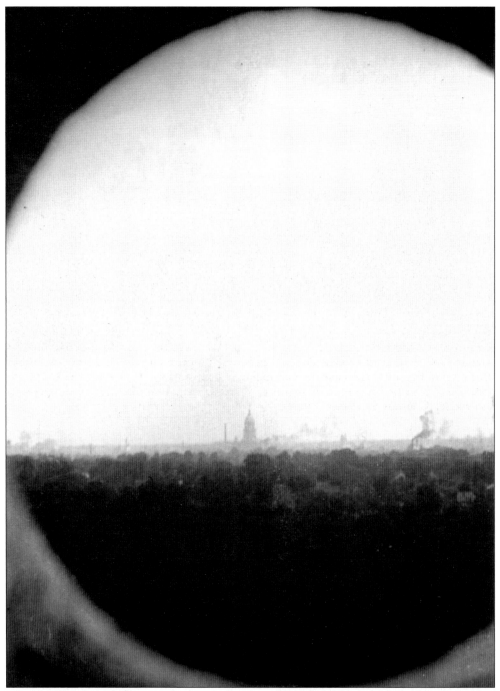

The Abraham Lincoln Monument Association wanted the president to be buried on the Mather block, which is now the site of the statehouse. Mary Todd Lincoln demanded the president be interred at Oak Ridge Cemetery located on Springfield's north end. This 1921 photograph brings the two sites together. Taken from inside the obelisk of the Lincoln Tomb, this image shows the statehouse on the horizon. The stairway to the top of the obelisk was eliminated in the 1931 reconstruction of the tomb. (Courtesy Abraham Lincoln Presidential Library.)

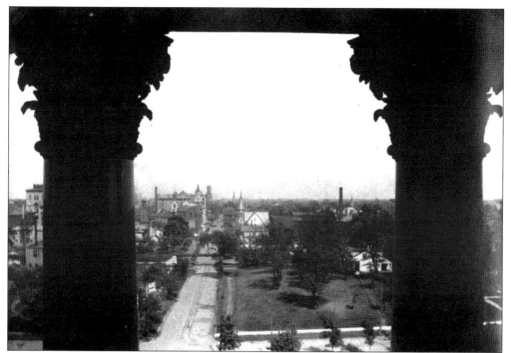

Around 1900, in this eastern view along Capitol Avenue, one can see the Prickett house (right), which is now the site of the supreme court building. The house was built around 1830 and was once one of the oldest houses in Springfield. The old Chicago and Alton Railroad overpass is also visible. (Courtesy Sangamon Valley Collection, Lincoln Library.)

In December 2001, the Prickett house is a distant memory with the supreme court building in its place.

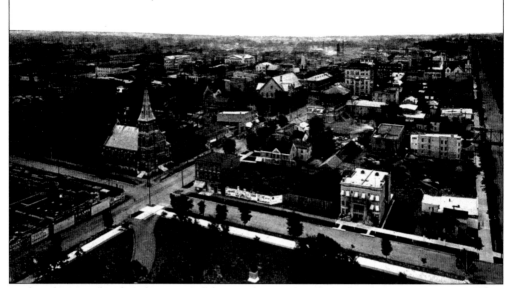

In this photograph taken from one of the statehouse's lower observation decks, the foundation work on the Illinois State Arsenal can be seen at the northwest corner of Second and Monroe Streets (left). The cornerstone of Trinity Lutheran Church, on the northeast corner, was laid in 1888, the same year the statehouse was completed.

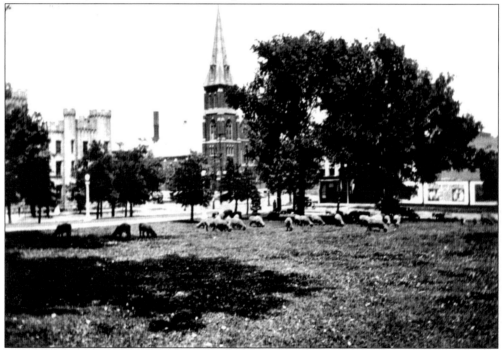

A June 12, 1918, *Illinois State Journal* newspaper article states that 225 sheep were brought from the state fairgrounds to the statehouse for the purpose of "mowing the lawn." Visible to the left is the Illinois State Arsenal, which was destroyed by fire in 1932. (Courtesy Abraham Lincoln Presidential Library.)

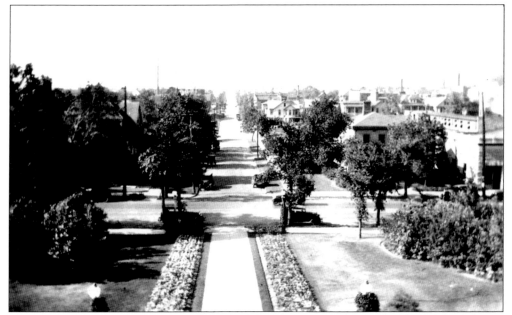

Pictured is First Street as seen from the second-floor balcony on the north side of the statehouse in 1925. (Courtesy Mark Mahoney, Clerk of the House.)

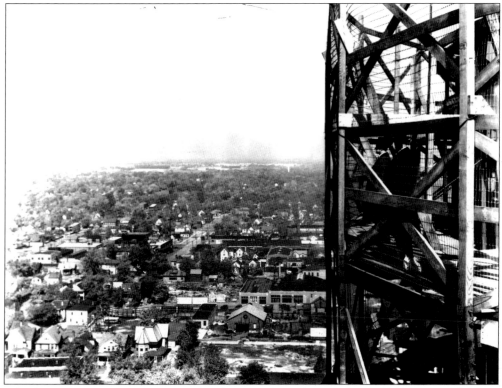

A bird's-eye view of Springfield's north side is seen from the wooden scaffolding erected during the 1932 dome reconstruction. The Lincoln Tomb is barely visible on the horizon. (Courtesy Abraham Lincoln Presidential Library.)

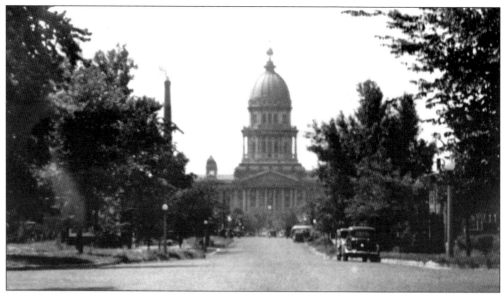

In multiple plans over the last century, First Street has been discussed as a possible promenade connecting the statehouse to the Lincoln Tomb (north of town). This image shows a rare view of the First Street approach to the statehouse's north entrance. (Courtesy Abraham Lincoln Presidential Library.)

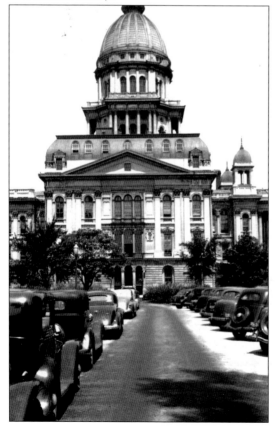

In this view of the south wing of the statehouse, parking is at a premium just as it is today.

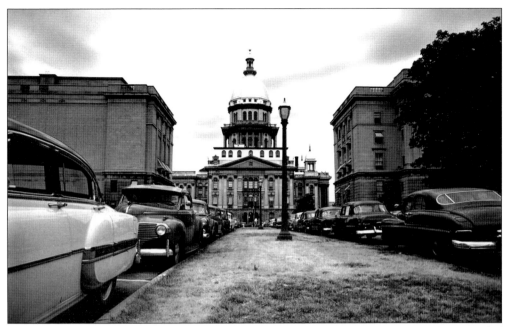

In 1954, the Centennial (now Howlett) Building, pictured on the right, has yet to be extended southwestward. This final addition was constructed in the mid-1960s. The Illinois State Archives, now known as the Margaret Cross Norton Building, is seen on the left. (Courtesy Secretary of State, Illinois State Archives.)

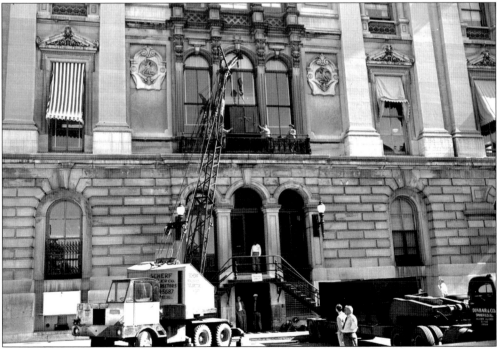

On the south side of the capitol, safes are being lowered from the second floor on June 4, 1954. At one time, millions of dollars in cash and securities were stored in statehouse vaults. (Courtesy Secretary of State, Illinois State Archives.)

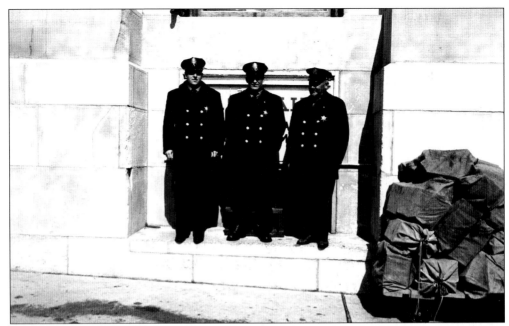

Three watchmen pose in front of the statehouse mail chute in March 1956. This was located on the south side of the building. (Courtesy Secretary of State, Illinois State Archives.)

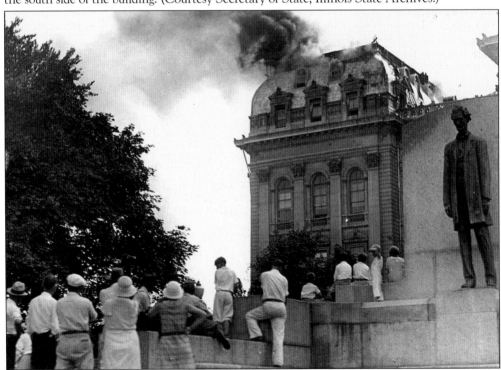

While the fire smolders in 1933, onlookers gather at the base of the Abraham Lincoln statue. Even Gov. Henry Horner (1933–1940) assisted with the efforts to protect the building and its contents. He directed that the historic paintings of Abraham Lincoln and Stephen A. Douglas in the house chamber be covered and protected. (Courtesy Abraham Lincoln Presidential Library.)

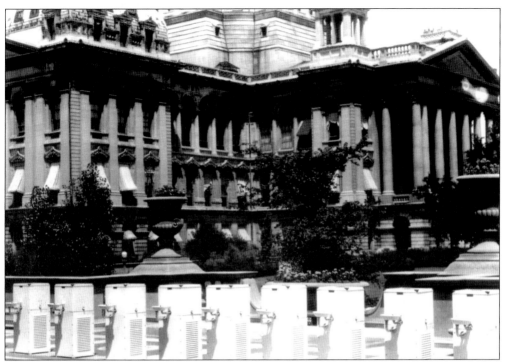

The parched throats of the capitol complex employees were soon to be relieved on this day as new drinking fountains were ready for installation. (Courtesy Secretary of State, Illinois State Archives.)

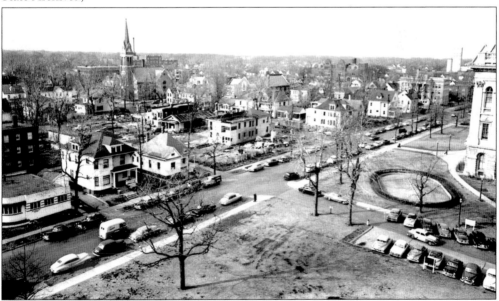

Just prior to the construction of the state office building (now the Stratton Building) in the mid-1950s, homes and businesses are still located close to the statehouse. A sharp eye reveals the old St. Agnes Church and, behind it, the present-day Springfield High School. The old Springfield High School may also be observed a couple of blocks to the east (right), near the horizon. (Courtesy Secretary of State, Illinois State Archives.)

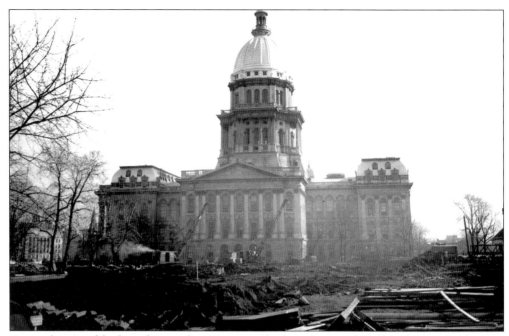

An unobstructed look at the statehouse's west side shows site work well underway for the new state office building (now the Stratton Building) in February 1954. (Courtesy Secretary of State, Illinois State Archives.)

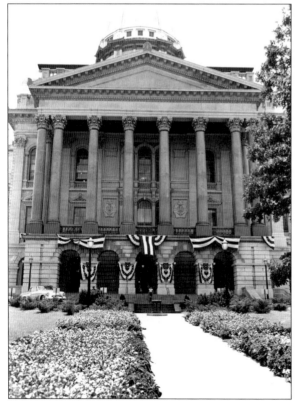

Seeing the statehouse decorated for the Illinois State Fair was once commonplace. In 1956, the north side is draped in patriotic bunting. (Courtesy Secretary of State, Illinois State Archives.)

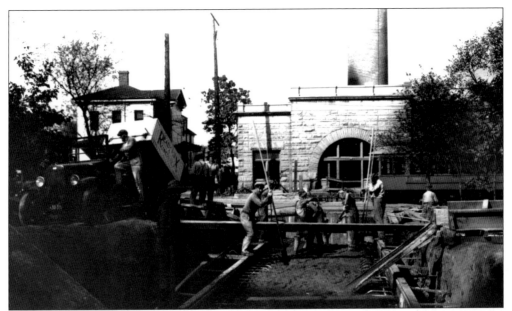

Workers in 1930 construct a concrete service tunnel underneath the statehouse grounds. It connected the old state powerhouse to the new annex of the Centennial (now Howlett) Building. During this project, remnants of the unused temporary tomb for Abraham Lincoln were discovered. In 1865, some Springfield residents were unaware of the change in plans and were surprised when Lincoln's funeral procession bypassed this site for Oak Ridge Cemetery. Also, notice the streetcar on Monroe Street behind the tree. (Courtesy Abraham Lincoln Presidential Library.)

For about 50 years, the State of Illinois generated the electricity used in the statehouse and other capitol complex buildings from a powerhouse across Monroe Street, just north of the building. Viewed from a north portico arch on August 25, 1954, workers may be seen atop the powerhouse smokestack during the process of dismantling it. Although today the smokestack is gone, the building is still in use by the state. (Courtesy Secretary of State, Illinois State Archives.)

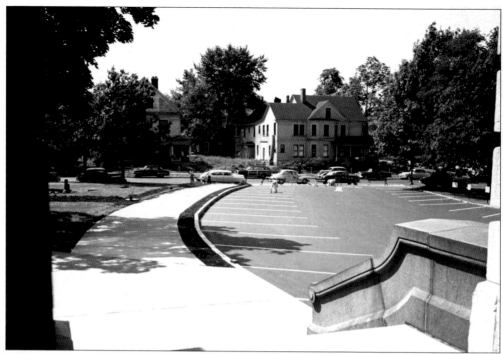

Workers are seen applying the finishing touches after the north drive was widened in August 1953. This westward view of Spring Street shows how the building was once closely surrounded by private residences. (Courtesy Secretary of State, Illinois State Archives.)

The statehouse is illuminated in 1901 for the inauguration of Gov. Richard Yates (1901–1905). His father was inaugurated for the same office in 1861. The years 1861 and 1901 appear above and below the word *Yates* in the display. The lit 10-foot star above the building was said to be visible for 40 miles. (Courtesy Sangamon Valley Collection, Lincoln Library.)

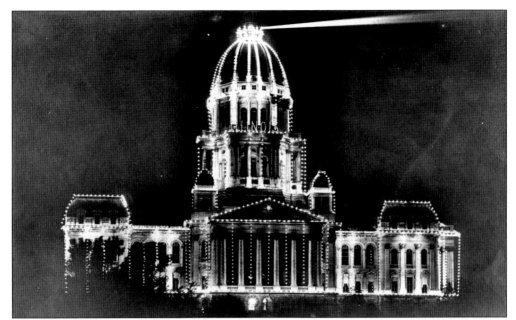

In the Illinois State Fair's early days, one might think it an early Christmas. In conjunction with the fair, the statehouse was elaborately decorated, and a carnival was held in downtown Springfield. In this photograph from 1907, just about every angle of the building is illuminated. (Courtesy Abraham Lincoln Presidential Library.)

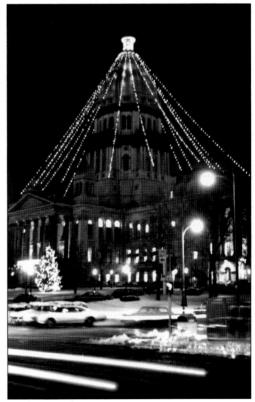

Weather permitting, the Christmas tree look has been a staple of the statehouse in recent decades. (Courtesy Abraham Lincoln Presidential Library.)

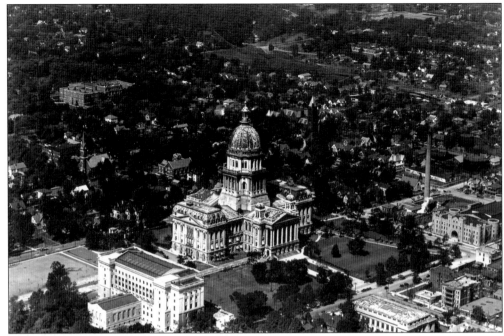

A 1920s aerial view of the statehouse and surrounding buildings is seen here. During this time, the additions to the Centennial (now Howlett) Building, located just left of the capitol, have not been constructed.

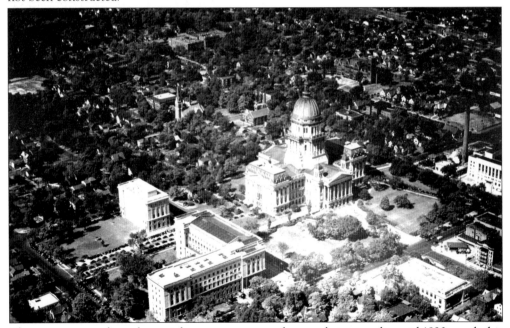

The area surrounding the statehouse saw many changes between the mid-1920s and this February 1953 aerial view. The Illinois State Arsenal had burned down and been replaced by the Illinois State Armory (right), and the Centennial (now Howlett) Building's east wing is completed (lower left). Also note the Illinois State Archives building, located just west (left) of the Centennial Building. (Courtesy Secretary of State, Illinois State Archives.)

In 1918, the State of Illinois celebrated its 100th anniversary of admittance into the union. As part of its centennial festivities, the state commissioned statues of Abraham Lincoln and Stephen A. Douglas. A 1913 appropriation funded the project, and the works were dedicated on October 5, 1918—the 100th anniversary of the first meeting of the Illinois General Assembly.

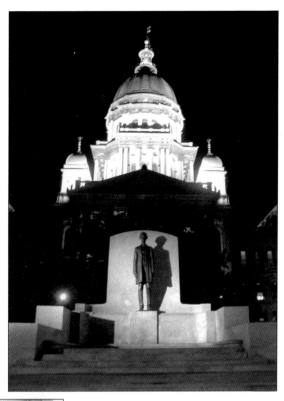

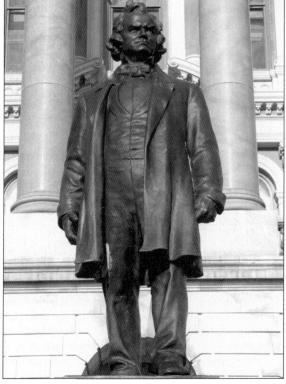

Stephen A. Douglas was known as the "Little Giant" due to his combination of short stature and great oratorical skills. This statue sculpted by Gilbert P. Riswold was originally located on the northeast lawn and is now found near the east entrance. In 1935, Secretary of State Edward J. Hughes (1933–1944) was unhappy with its location behind shrubbery and ordered the statue moved to its current location. A statue representing an Illinois coal miner is now located near Douglas's former space.

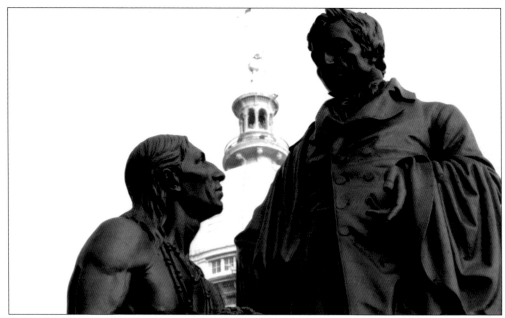

An eight-foot statue of Pierre Menard, Illinois' first lieutenant governor from 1818 to 1822, trading with a Native American was placed on the statehouse lawn on May 28, 1886. The dedication was held on January 10, 1888. The statue was originally situated on the northeast side of the building but was moved to the southeast side in 1918 to make room for the statue of Stephen A. Douglas.

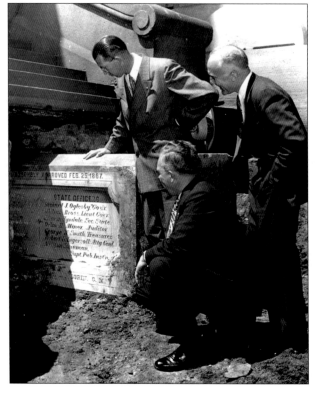

The original statehouse cornerstone developed cracks while the building was still under construction and had to be replaced in 1870. As the years went by, this was forgotten, and many theories developed as to why the stone was removed and what became of it. During a July 1944 construction project, the mystery was solved when the original cornerstone was discovered beneath the northeast steps near its former location. From left to right, Sen. Arnold J. Benson, state historian Paul Angle, and Secretary of State Richard Yates Rowe (1944–1945) inspect the recently uncovered stone. The replacement cornerstone may be seen just above Angle. (Courtesy Abraham Lincoln Presidential Library.)

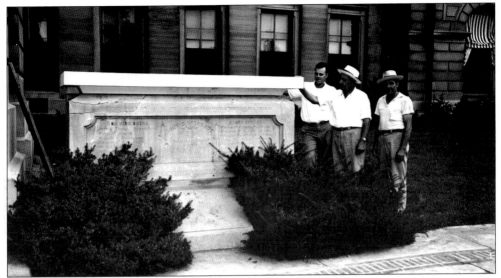

After its discovery, the original stone was displayed near the east entrance to the building. On July 19, 1955, workers are inspecting the refurbished original cornerstone. (Courtesy Secretary of State, Illinois State Archives.)

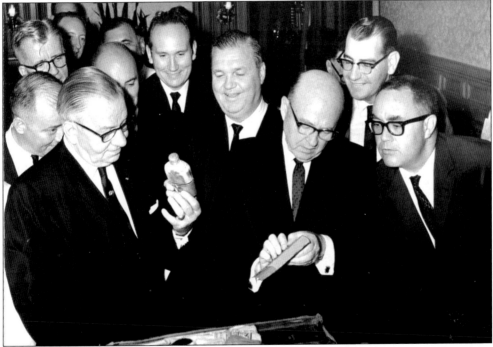

In 1968, dignitaries and historians removed the copper box containing numerous artifacts from the second cornerstone. Seen here, Secretary of State Paul Powell (1965–1970) holds a whiskey bottle gifted to Abraham Lincoln. Also present are Dr. Wayne "Doc" Temple (behind the flask); state auditor of public accounts Michael Howlett (1961–1969), his hand on the flask; grand master of the Illinois Masons Myron K. Lingle (holding the book), superintendent of grounds and buildings Thomas Owens (behind and right of Lingle), and Illinois state historian Clyde Walton (far right). (Courtesy Abraham Lincoln Presidential Library.)

Visible in this winter 1959 view from the east portico is the Abraham Lincoln Hotel, several blocks away on the right. The building was imploded in December 1978. This hotel, along with the Leland and St. Nicholas Hotels, were popular with legislators due to their close proximity to the statehouse. (Courtesy Secretary of State, Illinois State Archives.)

The east fountains used to operate year-round, creating a frozen landscape in front of the statehouse. The Leland Hotel may be seen on the left side of Capitol Avenue, near the horizon, while the pile of rubble on the right side of the street beyond the railroad tracks is all that remains of the Abraham Lincoln Hotel in February 1979. Also visible in this view is the present-day Hilton Springfield, the tallest structure in the background. (Courtesy Secretary of State, Illinois State Archives.)

Seven

CAPITOL AVENUE VIEWS

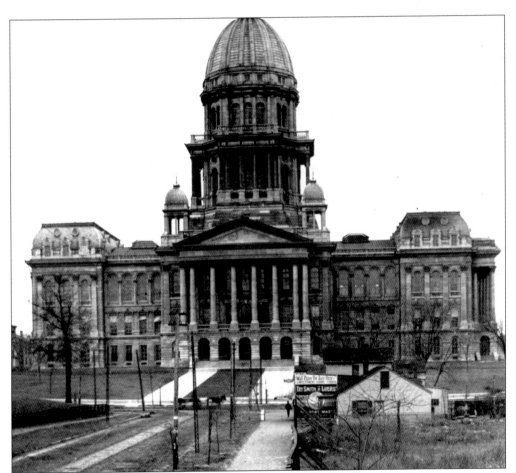

At the beginning of the 20th century, there was a scarcity of development directly east of the statehouse in its early days. Today these corners are occupied by the Illinois Supreme Court and State Library buildings. (Courtesy Abraham Lincoln Presidential Library.)

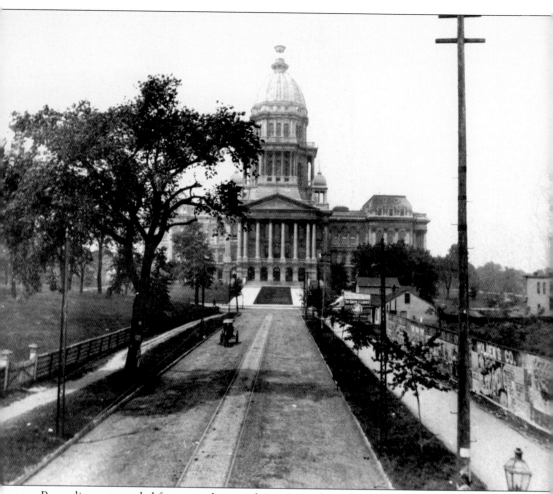

Power lines suspended from metal towers began providing electricity to streetcars around 1890. During this time, billboards served as fencing and advertising along downtown Springfield streets. (Courtesy Abraham Lincoln Presidential Library.)

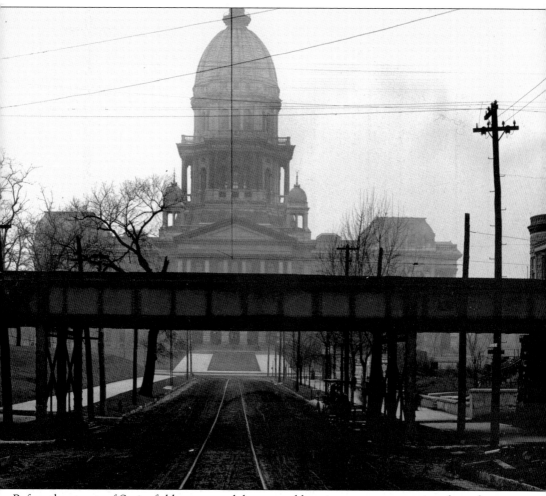

Before the streets of Springfield were paved, horses and buggies were common sites throughout the city. Citizens and visitors had to battle the mud and street conditions. As seen here, streetcar tracks were laid in the middle of Capitol Avenue and turned south along Second Street. (Courtesy Abraham Lincoln Presidential Library.)

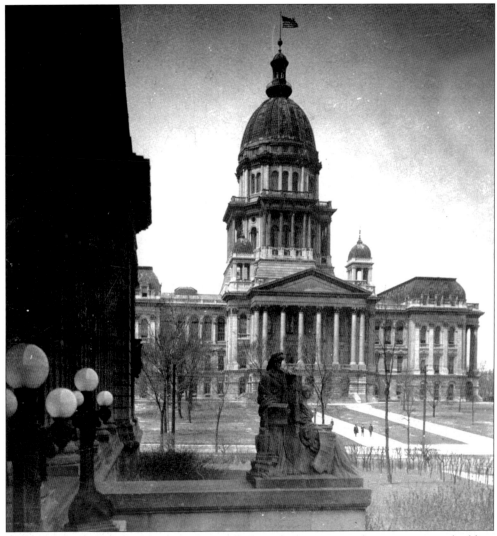

The statue in the foreground is one of a pair flanking the entrance to the supreme court building and was created by artist Charles Mulligan. He was a student of famous Illinois sculptor Lorado Taft, as were several artists responsible for statues inside and outside the statehouse.

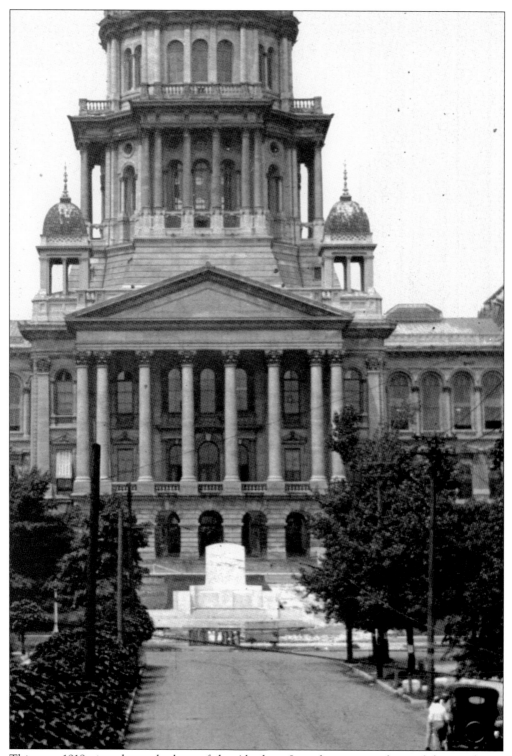

This rare 1918 view shows the base of the Abraham Lincoln statue in front of the statehouse before the sculpture was placed.

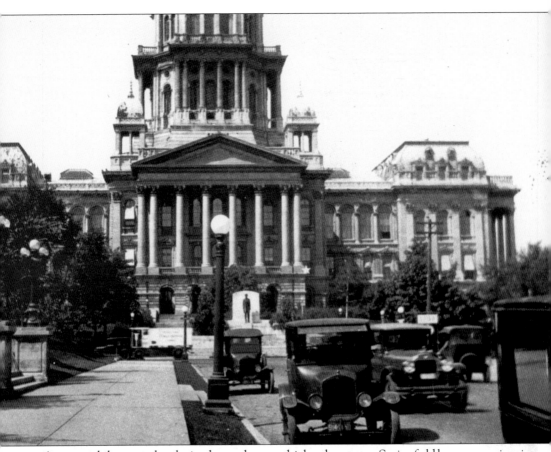

As automobiles started replacing horse-drawn vehicles, downtown Springfield began experiencing the modern headache of traffic congestion. (Courtesy Abraham Lincoln Presidential Library.)

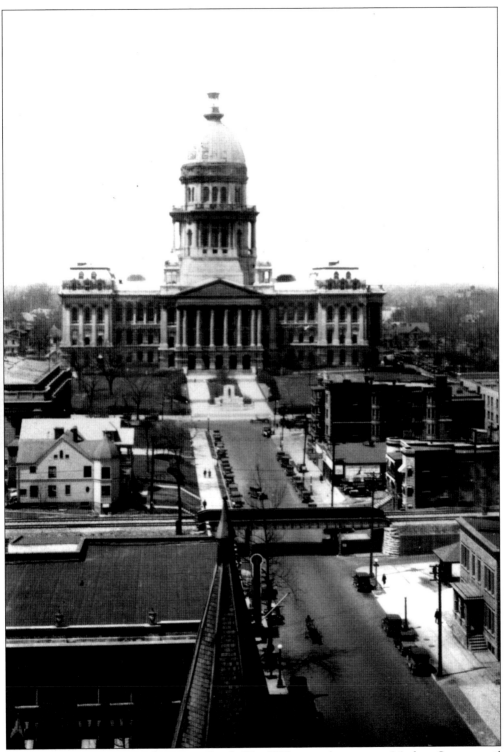

Capitol Avenue, as seen here on April 26, 1928, was known as Market Street until around 1882.

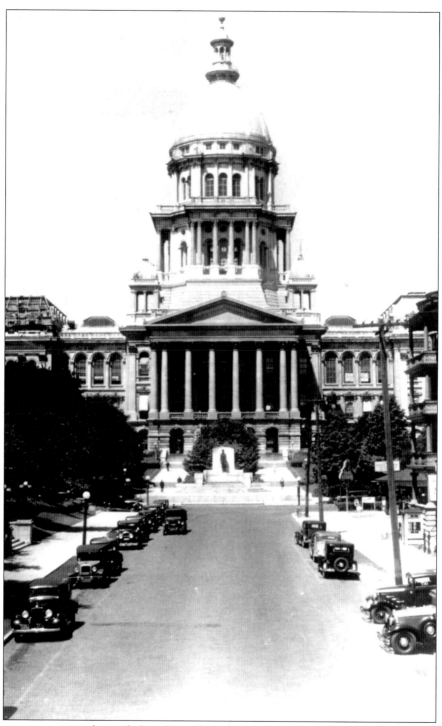

Parking spaces were in demand along Capitol Avenue in the early 1930s. Automobile dealerships and gas stations could be found only blocks from the statehouse. Keep a sharp eye out for the repair work being performed on the south wing roof following the fire of 1933. (Courtesy Abraham Lincoln Presidential Library.)

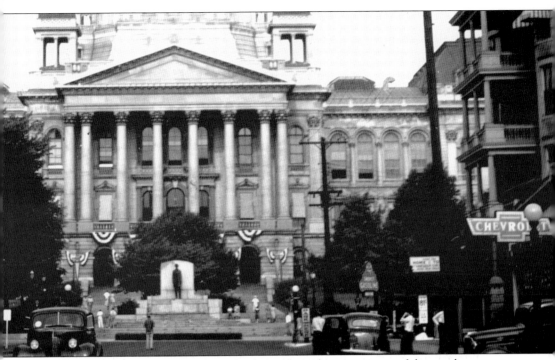

In this photograph, taken on August 10, 1941, bunting on the east portico of the statehouse may indicate that it was Illinois State Fair time in Springfield.

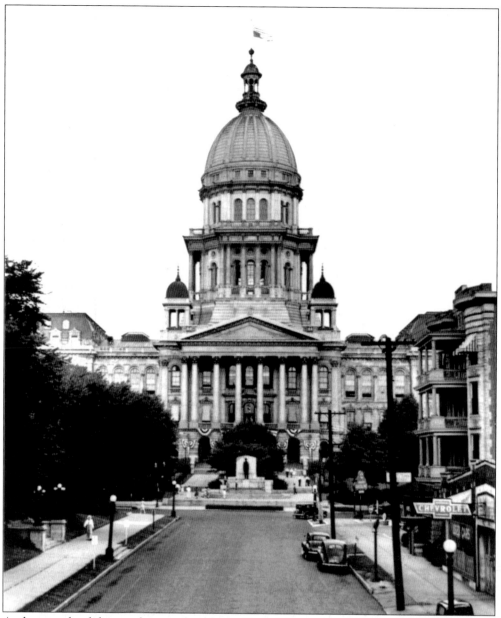

A photograph of the statehouse taken down Capitol Avenue is fairly common. However, the United States flag pictured in the upside-down, "distressed" position is quite unique. Evidently, an employee mistakenly hung the flag in this position on this August day in 1941. (Courtesy Sangamon Valley Collection, Lincoln Library.)

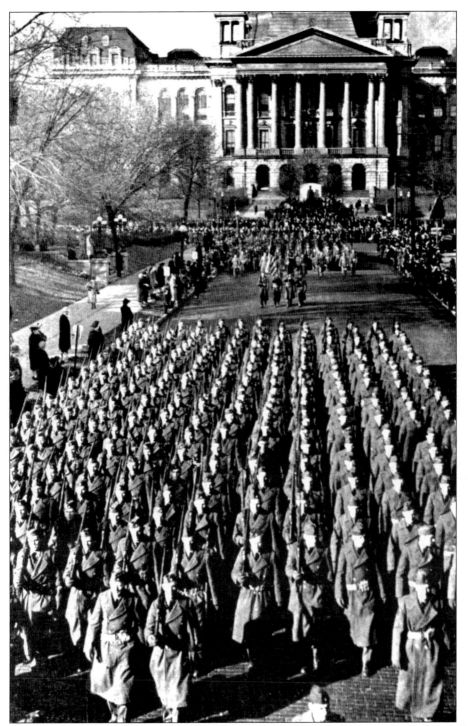

Capitol Avenue has been the site of many veterans parades over the years. Only days before the Japanese attacked Pearl Harbor (December 7, 1941), on November 11, 1941, solders march down the avenue to commemorate America's victory and the end of World War I. (Courtesy Sangamon Valley Collection, Lincoln Library.)

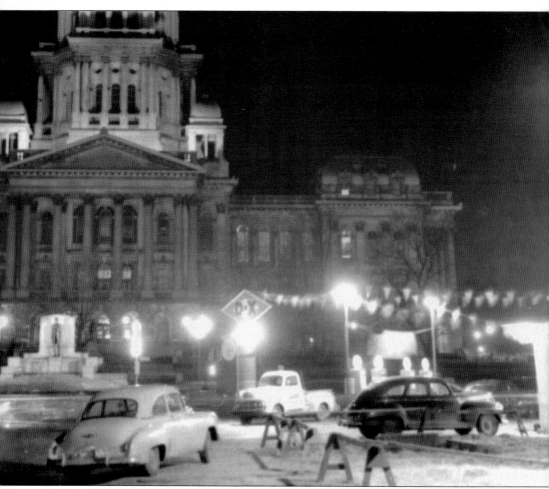

The northeast corner of Capitol Avenue and Second Street has been the home of several businesses throughout the years. In this image from January 11, 1955, a DX service station operates at this location. (Courtesy Secretary of State, Illinois State Archives.)

The camera of Eddie Winfred "Doc" Helm captured the activity around the statehouse in this clear image taken on July 8, 1954. (Courtesy Secretary of State, Illinois State Archives.)

ACROSS AMERICA, PEOPLE ARE DISCOVERING
SOMETHING WONDERFUL. *THEIR HERITAGE.*

Arcadia Publishing is the leading local history publisher in the United States. With more than 3,000 titles in print and hundreds of new titles released every year, Arcadia has extensive specialized experience chronicling the history of communities and celebrating America's hidden stories, bringing to life the people, places, and events from the past. To discover the history of other communities across the nation, please visit:

www.arcadiapublishing.com

Customized search tools allow you to find regional history books about the town where you grew up, the cities where your friends and family live, the town where your parents met, or even that retirement spot you've been dreaming about.